ART ADVENTURES AT HOME

A Curriculum Guide for Home Schools

LEVEL 1

A foundational art program geared toward the early elementary grades

by Pattye Carlson and M. Jean Soyke

illustrated by Pattye Carlson

Printed 2005

TABLE OF CONTENTS

HOW TO USE THIS BOOK

About the Program

Art Adventures at Home is a total art curriculum for children in grades K-8. The curriculum section of each book presents a three-year art program, with 35 lessons per year. In the first two books, all of the objectives for the level are presented in the first year, while activities in the second and third years reinforce the concepts already introduced. Most people will want to do one art lesson per week, perhaps supplementing with art activities related to other subject areas, seasonal crafts, and/or art-related field trips.

Grade Placement

The lessons for this volume are written for students who are beginning kindergarten, first, or second grades. It can also be used as an introductory program for an older student who has had little previous art experience. In this case, the student should complete Year A of this level and then move on to Level 2.

Parents with several children may wish to group their children, placing those in grades K-2 together, those in grades 3-5 together, and those in grades 6-8 together. Each group can then begin at their appropriate level and continue their art instruction together throughout their elementary years. Since the same five units are covered each year, parents with children on different levels will be able to teach art to all their children at the same time, using essentially the same materials but with different activities and/or objectives.

Teaching the Lessons

Each lesson in Art Adventures at Home is designed to be followed step-by-step. It is recommended that you read each lesson thoroughly before it is to be presented, perhaps even

trying the project first to make sure the process is understood. (There is a description of a lesson plan on the next page to give you an idea of what each section of the lesson involves.) If all the necessary materials are gathered, prepared, and organized ahead of time, the art lesson will go much more smoothly.

Although this curriculum is highly structured, there is plenty of room for flexibility. For example, blank lesson-plan pages are included at the end of each year so that you can design your own lessons, if you wish. It is recommended that you teach Year A exactly as written, but you may want to switch a lesson in Year B with a lesson from Year C that covers the same objective. We do not recommend that you change the order of the lessons within a unit; however, the order of the *units* may be changed during any given year. (We have placed a line on each page for you to write the date; this will help keep track of any changes that you make.) Even though the program is well-structured, please remember that it is only a tool. Let your child's readiness and interest dictate the course of your instruction. Feel free to omit a lesson if your child is totally frustrated or uninterested, or change the focus of the lesson if your child is interested in a different aspect of it. Let this curriculum serve your needs!

Some of the lessons suggest that the child look at particular samples of art. Usually an encyclopedia will yield one or two useful examples, but a visit to the art history section of your library is likely to prove more fruitful. (Look especially for books by V. M. Hillyer, who has written several books on art history for children. Some of his books are part of the Calvert School curriculum, which is used by many homeschoolers.) Also, Homeschooling Today magazine (P. O. Box 1425, Melrose, FL 32666-9988) features a pull-out section with a full-page color reproduction of a famous work of art in each issue. Parents who want to invest further in art reproductions may want to consider purchasing copies from Art Extension Press, Box 389, Westport, CT 06881 (phone 203-256-9920; leave your name and address to receive a brochure) or from the National Gallery of Art, Publication Dept., 6th and Constitution Aves. NW, Washington, DC 20565 (phone 301-322-5900; ask for a Publications Catalog). A final source for art samples are educational games, such as Aristoplay's "Artdeck" and Safari's "American Art Quiz" and "American Art Rummy". (Check your local store where educational games are sold.) A resourceful parent who plans ahead should have little difficulty finding appropriate art samples.

We have confidence that this curriculum will not only enable you to teach your child the fundamentals of art, but it will also provide some fun, challenging, and rewarding experiences for your family.

SAMPLE LESSON PLAN

LESSON FORMAT **(Title)** **Date** _____

BIG IDEA: This is the art concept being taught. *(See page 9.)*

GOAL: This tells how the child will demonstrate his knowledge of the concept in a particular art project.

MAIN ELEMENTS: This tells which of the four elements of art is emphasized (line, shape/form, color, or texture)

MATERIALS: This section lists all of the art materials you will need.

STRATEGY:

This is the **teaching** section of the lesson. It describes exactly how to prepare the child for the art project. Generally, some ideas for motivating the child are given first, then suggestions are given for presenting and discussing the concept. These are followed by step-by-step instructions for demonstrating the technique.

WORK PERIOD:

This is the **learning** section of the lesson. It tells exactly what the child will be doing, including specific directions for the child to demonstrate the concept being emphasized.

QUESTIONS FOR EVALUATION AND REVIEW:

Specific questions are given for you to ask the child. Some questions will help you determine the child's understanding of the concept and technique being taught. Other questions (such as, "How do you feel about your project?") encourage self-evaluation and introduce the child to techniques of art appreciation.

WHY ART?

In the beginning, God gave an amazing gift whose only purpose was to bring pleasure. The gift is evident in the design, form, textures, and vibrant hues we see in nature-- the animal kingdom, mountain ranges, flowers, gems, jungles, and the ever-changing sky. The gift is beauty. It has the power to stir our emotions, renew and refresh us, and stretch our imaginations. When we experience *art*, we participate in the same creative process, and in this way receive and reflect back to our Creator the gift of beauty.

Yet, for teachers and parents, art is more than the means through which beauty is created. Art education is a valuable tool, for it reinforces learning through multisensory experiences. It is especially suited for visual and kinesthetic learners-- those who learn best by seeing and doing-- while benefitting auditory and kinesthetic learners by increasing skills in visual perception. Furthermore, art education is a useful tool for developing:

- sensory perception (ability to see, understand, gain meaning)
- thinking skills (examine, compare, evaluate, analyze, solve problems)
- communication of thoughts and feelings
- positive self-regard as successes are experienced in creating beauty
- an increased capacity for enjoying beauty

Sadly, at different times and places, movements have arisen in protest of art. For example, the Dark Ages was a period in history when beauty and creativity were suppressed in all forms. As parents teaching art, however, we look to the Creator as our example. He is the first and ultimate Artist; color, line, shape, form, texture-- all are His design. From the Garden of Eden, to the purple and scarlet fabrics of the "excellent wife", to the heavenly streets of precious stone, God has revealed Himself as a God of beauty. Beauty is His gift to us; it is in His image that we are made creative. Being stewards of beauty and creativity means that we acknowledge and enjoy His creation and use these gifts to develop ourselves and our children as art is so uniquely suited to do.

TEACHING ART

If we are indeed stewards of the creativity God has given us, how do we convey this to our children? How can our art lessons encourage children to express their creativity in a purposeful manner? Perhaps the right way to teach art can best be discovered by exploring some *wrong* ways to teach art.

Giving the child pre-designed materials

It makes life much simpler when we can hand a coloring book or adult-designed stencils to a child and call it "art class". The truth of the matter is, however, that "art" such as this requires little thought or creativity on the part of the student. The child is not free to stretch his imagination, learn about new materials or processes, express an idea or share what has been perceived. We must even be careful in choosing projects that must be done "just so"; although certain art processes have definite procedures, there must be room left for the child to plan how he will arrive at the end product he has designed. Studies have shown that pre-planned "art" actually inhibits creativity and causes children to regress in their ability to express themselves artistically.

Over-emphasizing neatness

Some of us may become a bit anxious when we consider the potential mess an art project can bring, but we need to be careful not to limit our projects to neat and tidy ones. Several things can be done to minimize the mess associated with the creative process. First, demonstrate individual techniques with neatness in mind. When using glue, for example, demonstrate how to apply glue with a fingertip, teaching your child that "a little dab will do ya". It is also important to show young painters how to remove excess paint from their brushes by drawing the brush along the lip of the paint container. Second, develop a clean-up routine. One rule that may help is "hands are washed before smocks come off".

As far as the finished product is concerned, we should encourage a child to do his best work, but should also accept a project even if the edges are slightly askew, or the paint ran a

little. Placing too high a priority on neatness can actually inhibit our child's creativity and lower his self-esteem.

Giving too little direction

We've already explained how an art teacher can unwittingly inhibit creativity. This does not mean, however, that you should just give your child some art materials with some instructions and then go off and do the laundry. Studies have shown that children left completely to themselves in the art realm become frustrated, bored, and/or discouraged. The key to good art instruction is a balance of freedom and direction. Your child should be in control of the ideas and the development of the project; he also needs freedom to explore ways in which he might reach the goal he has selected for his project. When your child comes to a "dead end", however, you need to be there to offer assistance. Avoid giving answers; ask questions and encourage your child to solve his own problems. There may also be times when you may need to re-teach a step or method. As you work through some art projects together, you will learn how to guide your child through an art experience that is both satisfying and challenging.

There is also something to be said for doing an art project along with your child. Not only are you available for assistance and direction, but you will have a good sense of any rough spots that the child may encounter in the process of executing the project. Working alongside another is also a wonderful facilitator of communication. Both children and adults are often amazingly willing to open up and share personal thoughts while their hands are occupied (hence the popularity of the old-fashioned "quilting bees"). In addition, you are conveying an important message to your child that art is both a pleasurable and worthwhile activity. (There is one danger in this approach, however. You may need to "hide" or abandon your project if you discover that your child is measuring the value of his project by comparing it to yours.)

Passing judgment on your child's art

"How do you like my painting?" our child asks, and we, being proud and enthusiastic parents, exclaim, "That's beautiful-- wonderful-- really great!" As natural as this is to do, our children need us to resist the urge to respond this way automatically. Since one of our goals is to help our children develop an intrinsic appreciation of their art, we must bear in mind that

6

continuous praise may easily lead a child to use his art merely as a means of gaining approval. We can give more helpful feedback by responding, "Tell me about your painting," or "How do *you* feel about your drawing?" Your child may share an imaginative story to explain what's going on in the work. Or, maybe he will express frustration in a certain area, thus giving you the opportunity to facilitate some problem-solving. Once you've listened to your child's thoughts, it is often meaningful to give a compliment that is a specific, simple observation: "I see you chose all oranges and reds; it really gives your picture a warm feeling," or "The way you repeat this shape really makes for an interesting pattern." This will reinforce the concepts being learned, facilitate intrinsic appreciation, and help prevent praise-dependency.

A word about grading

You may be in a situation where you are required to present a "grade" for your child's art work. It is *not* appropriate to grade solely on the appearance of the final project, nor is it appropriate to give young children letter grades for art. The following questions can help you arrive at your final assessment of the project.

- Did the student meet the basic goal as stated in the lesson plan?
- Did the student strive toward good craftsmanship?
- Does the project express a new perspective or original thought?

With these obstacles removed, your child's natural creativity will flow more freely in your art sessions. Offer your support. Help your child slow down long enough to *see*. Pique interest with trips to museums and unusual places to draw. Provide a variety of supplies and plenty of opportunity to use them. Most important, discuss design and beauty as it pertains to the things they experience every day. This type of an art program will develop an inner sensitivity and enjoyment of art that will impact your child for life.

MATERIALS NEEDED FOR ART AT HOME

Items to Buy

☐ Waterproof smock

☐ Paint brushes (fat and thin)

☐ Water color markers

☐ Colored chalk

☐ Crayons (64-pack)

☐ White paper (8 X 11, 8 X 14, and 11 X 17)

☐ Fingerpaint paper (Freezer paper works well for this.)

☐ Rubber cement *(Year A only)*

☐ Construction paper of varying colors

☐ Glue stick and white "school" glue

☐ Adult-quality scissors with blunt tips

☐ Self-hardening clay

☐ Mod Podge® craft gloss

☐ Metylan® instant wallpaper paste, for papier mâché *(Year C only)*

☐ Fingerpaints

☐ Pariscraft® plaster strips *(Year C only)*

☐ Liquid tempera paints (red, blue, black, brown, magenta, green, yellow, white. Get twice as much of the yellow and white- they are used more and tend to run out more quickly.) *(NOTE: Crayola® tempera paints have a gel consistency and can therefore double as fingerpaints.)* You may also wish to buy a separate paint cup and brush for each color, especially if you are using an easel. A cupcake tin is good for table work.

Items to Collect

☐ Old magazines and newspapers

☐ Yarn and rope in various colors

☐ Fabric scraps

☐ Styrofoam meat trays

☐ Old sponges

☐ Old manila folders

☐ Old toothbrushes

☐ Cardboard boxes & tubes (various sizes)

☐ Plastic container for water

☐ Small jars with lids

☐ Paper plates (for mixing paint colors)

☐ Old muffin tins (for holding paints)

☐ Gadgets for rubbings or clay work (ex., nuts and bolts, buttons, coins, lace, pasta shapes, feathers, leaves, bark, chains, combs, pebbles, checkers, paper clips, hair pins, shells, etc.)

OBJECTIVES

The following list outlines the basic concepts that are taught in this curriculum. Each lesson plan will cover one or more of these concepts, although not necessarily in this order. If you are developing your own lesson plans, you will want to refer back to this list to make sure all of the material is covered. (NOTE: All of these objectives are covered each year.)

ART ELEMENTS	CONCEPTS
Line	Lines can create shapes. (L1) Lines can suggest action and movement. (L2) Lines can create texture and detail. (L3) Lines can be used to express an idea. (L4) Lines can show various emotions. (L5) Lines can be repeated to create rhythm. (L6)
Shape/Form	Shapes can be repeated to suggest movement. (S1) Shapes can be combined to make objects. (S2) Shapes can be repeated to create patterns. (S3) Large shapes emphasize an object's importance. (S4) Shapes can be repeated to unify a design. (S5) Forms can be representational or non-representational. (F1) Forms can be useful (crafts). (F2) Forms have roundness. (F3)
Color	Colors can be mixed to make new colors. (C1) Colors can be warm or cool. (C2) Colors can suggest a mood. (C3) Colors can be repeated to create patterns. (C4) Colors can be repeated to unify a design. (C5)
Texture	Texture adds detail and interest. (T1) Textures can be very smooth to very rough. (T2) Textures can be visual or tactile. (T3) Textures can be repeated to unify a design. (T4)

YEAR A - PROJECTS

Unit I - Drawing

1. Shape Making
2. Still Life
3. Action and Movement of Lines
4. Story Pictures
5. Crayon Etching
6. Line Designs
7. Something Special

Unit II - Print-Making

8. Leaf Prints
9. Crayon Rubbings I
10. Crayon Rubbings II
11. Gadget Printing
12. Styrofoam Printing
13. Splatter Stencilling
14. Sponge Stamping

Unit III - Painting

15. Introduction to Color Mixing
16. Wax Resist
17. Non Representational Designs
18. Finger Painting
19. Rubber Cement Batik
20. Experimenting with a Variety of Paints
21. Experimenting with a Variety of Painting Tools

Unit IV - Sculpture

22. Introduction to Clay
23. Clay Animals I
24. Clay Animals II
25. Sculpture from Found Objects I
26. Sculpture from Found Objects II
27. Clay and Plaster Bas Relief I
28. Clay and Plaster Bas Relief II

Unit V - Crafts

29. Straw Weaving I
30. Straw Weaving II
31. Sand Paintings
32. Pinch Pots I
33. Pinch Pots II
34. Shadow Puppets
35. Stencil a Border

BIG IDEA: Lines can be combined to make shapes. (L1)

GOAL: The child will explore shape-making possibilities using a variety of lines.

MAIN ELEMENTS: Line, shape

MATERIALS:
Pencil
Glue
Paper
A wide variety of "lines" (ex., toothpicks, spaghetti, yarn, pipe cleaners, popsicle sticks, rubber bands, "twisties", cut straws)

STRATEGY:

• Ask "What makes something a shape?" Brainstorm and make a picture-list of as many basic shapes as you can remember. Then continue your picture-list with everyday shapes: outline of a leaf, house, person, etc. Next ask, "What is it that all of these shapes have in common?" Help your child see that a shape is the outline of a particular form and that it is completely closed-- one continuous line.

• With your finger in the air, trace the shape of several objects in the room.

WORK PERIOD:

• Using glue, paper, and "lines", the child makes three of each:
 - basic geometric shapes (square, triangle, circle, etc.)
 made up, "curvy" shapes
 - shapes of five or more straight lines each

• The child draws the shape (simple outline only) of three objects in the room.

QUESTIONS FOR EVALUATION AND REVIEW:

How do lines make shapes? *(They go all the way around a form.)*

What part of a form is the shape? *(The "outside", or the edges)*

Look at the shapes you made. Which shapes stand for (represent) things, and which did you make up? Could the made-up shapes stand for something (maybe a funny kind of building or a rain puddle)?

Look at some clouds. What do the shapes look like to you?

BIG IDEA: Shapes can be combined to make objects. (S2)

GOALS: The child will see shapes within a picture.
The child will combine shapes to make a picture.

MAIN ELEMENT: Shape

MATERIALS:

Magazines with lots of pictures
Tangram, or paper cut into an assortment of geometric shapes *(See next page.)*
Paper
Markers or crayons

STRATEGY:

• Select a full-size picture from a magazine to help your child see the various shapes in the picture. Have the child trace over shapes within the picture, using his or her pointer finger. (NOTE: Do not name shapes except to use descriptions such as "a squiggle here, with a straight line there", or "like a circle, only flattened". We want to encourage <u>seeing</u> and discourage the tendency to rely on symbols-- triangles for noses, for example.)

• Make objects using a tangram or paper geometric shapes.

WORK PERIOD:

• The child draws a still life of toys, kitchen utensils, tools, or an area of the room, paying special attention to the inner shapes. (Choose objects whose comprising shapes are more obvious than subtle.)

QUESTIONS FOR EVALUATION AND REVIEW:

Trace the shapes within the drawing, using your finger and showing where on the object those shapes (edges) were seen.

How do you feel about the drawing?

TANGRAM

Trace or copy onto cardboard or heavy paper.

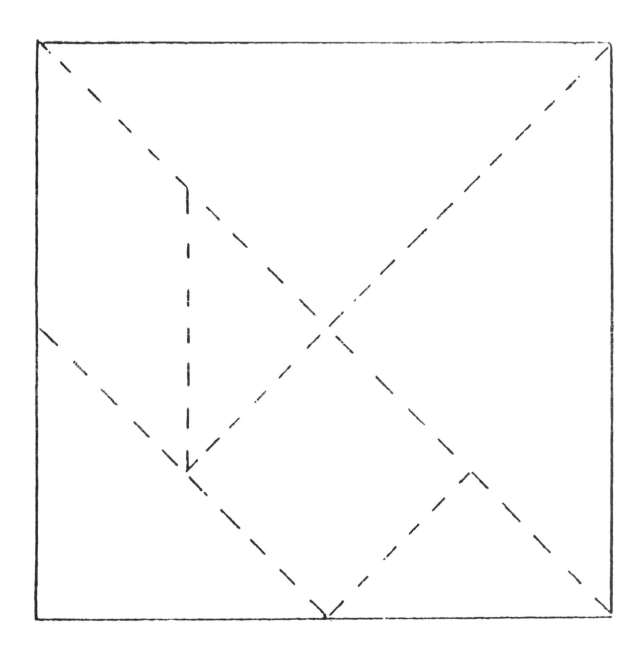

SAMPLES OF LINE

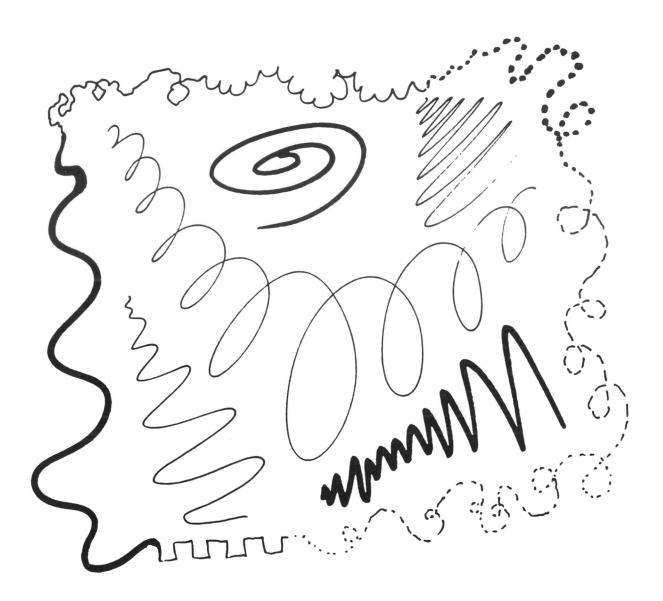

BIG IDEA: Lines can suggest action and movement. (L2)

GOAL: The child will use various kinds of line to create action and movement in a drawing.

MAIN ELEMENT: Line

MATERIALS:

Markers
Drawing paper
Comic section of newspaper
Scissors
Glue

STRATEGY:

• Look at the comic strips and cut out 6-10 examples of movement and action. Glue these to a piece of drawing paper or tagboard. Help your child identify the specific lines that show the movement. (You may want to cover the lines to see what difference it makes in the pictures.) Explain that a person who draws the comic strip is called a "cartoonist". (You may also want to find the cartoonist's name and/or signature in the strip.)

• Brainstorm a list of action words (verbs) and write them down. Include high-energy words (ex., "jump", "run", "dance") as well as low-energy words (ex., "think", "dream", "hear").

• Talk about and draw in the air the kinds of lines that match the action words on your list. *(See samples on the previous page.)*

WORK PERIOD:

• The child selects an action word from the list and decides which type of line would best illustrate this kind of movement.

• The child spends the rest of the work period drawing lines. (NOTE: Some children will work quickly and enthusiastically with this project and may wish to do several.)

QUESTIONS FOR EVALUATION AND REVIEW:

Tell me about the action you chose.

Which area(s) has the most energy? How did you get that energy there?

| **BIG IDEA:** | Lines can be used to express an idea. (L4) |

| **GOAL:** | The child will make a line drawing to express an idea. |

| **MAIN ELEMENT:** | Line |

| **MATERIALS:** | Paper |
| | Crayons or markers |

| **STRATEGY:** |

• Ask, "Did you know that lines can tell a story?"

• Explain that drawing a story is different from drawing a still life. "You will be drawing a picture from your imagination. You will not be drawing something you are seeing with your eyes."

• Discuss what kind of story your child would like to draw. Here are some ideas:
 Wishes- "My Best Day Ever"; "When I'm Grown Up"
 Dreams- "Last Night I Dreamed..."
 Events- "My Vacation"; "My Day at the Zoo"; "My Birthday Party"

• Encourage your child to fill the page, using large strokes with lots of detail.

| **WORK PERIOD:** |

• The child decides on a story and a title.

• The child spends the remaining time drawing the story. (NOTE: With large drawing paper, children manage best with the paper attached to an easel or wall.)

| **QUESTIONS FOR EVALUATION AND REVIEW:** |

Tell me what is happening in your story.

Why do you think it's important to fill the page? What does a picture look like if it has a lot of empty places?

What do you like about your drawing?

LESSON 5, YEAR A **Crayon Etching** Date_____

BIG IDEA: Texture adds detail and interest. (T1)

GOAL: The child will work with repeating lines to give textural interest and detail to a crayon etching.

MAIN ELEMENT: Line

MATERIALS:
Smock
Newspaper
Paper, prepared by drawing an 8" X 10" rectangle on it
Crayons
Black tempera paint (or other dark color)
Liquid soap detergent
Etching tool (toothpick, nutpick, nail, old pen, straightened paper clip)

STRATEGY:

• Explain the concept: "Lines can be wavy, straight, or jagged. We can make our drawings more interesting by repeating lines. This gives a picture **texture**."

• Explain the etching process: "First we'll color our paper with crayons. We can use only one color or lots of different colors. *(Demonstrate how to color using heavy strokes.)* Next we'll cover our paper with paint. When the paint is dry, we will scratch out lines so that the color shows through. This is called 'etching'."

• Help your child select a subject or scene that has at least three different textures. (For example, a flower could have smooth lines on the petals, jagged lines on the stem, and wavy lines for the grass or pot beneath.)

WORK PERIOD:

• The child colors the 8" X 10" rectangle, leaving no white spaces.

• The child covers the area with paint to which a few drops of liquid dish detergent has been added. (This helps the paint adhere to the waxy surface.)

• While the paint is drying, have the child sketch his drawing on a separate sheet of paper. Talk about repeating different kinds of line to fill in an area. Notice how the lines give different areas interest and detail.

• When the paint is dry, have the child etch the drawing, using at least 3 different textures.

QUESTIONS FOR EVALUATION AND REVIEW:

What areas of your etching do you like the most? Are there any areas that could be made more interesting?

BIG IDEA: Lines can show various emotions. (L5)

GOAL: The child will use line to depict an emotion in a drawing.

MAIN ELEMENT: Line

MATERIALS: Black marker
Paper

STRATEGY:

• Have your child draw different kinds of lines (fat, thin, jagged, spiral, wavy, dotted, dashed, light, dark, curvy, etc.) Refer back to page 16 for some ideas.

• Have your child name all of the emotions he can think of. List these on paper or chalkboard.

• Go over each emotion, one at a time. Ask your child to draw a line that would describe that emotion next to its name. (For example, a child may associate a thin spiral with a sad feeling; a happy feeling may be represented by a large, jagged line.)

WORK PERIOD:

• The child selects one emotion he would like to depict.

• Discuss with your child what kinds of line would express that feeling.

• The child uses two or more different kinds of line to fill the page.

QUESTIONS FOR EVALUATION AND REVIEW:

What lines did you choose for your design? Why?

Does your design feel the way you wanted it to feel? Why or why not?

BIG IDEA: Large shapes emphasize an object's importance. (S4)

GOAL: The child will draw an assortment of things that are special to him, emphasizing one item which is most important by making it larger than the others.

MAIN ELEMENT: Shape

MATERIALS:
> Drawing paper
> Markers
> Special possessions
> Pictures from an encyclopcdia or art book of paintings by Degas
> > (especially those of horses and ballerinas) *(optional)*

STRATEGY:

• Have your child gather about five of his favorite possessions.

• Explain that sometimes artists draw or paint things that are special to them. If you have the pictures of Degas' works, look at them together.

WORK PERIOD:

• Have the child decide on the one possession that is the most special.

• Child points to the place on the paper where the most special possession will go. Explain that one way to show that something is special is to make it larger than the other objects.

• Have the child draw his special object first; it should be large.

• The child completes the drawing by adding the other objects, which should be smaller in size that the special object.

QUESTIONS FOR EVALUATION AND REVIEW:

Do you see how making your _____ extra large shows how special it is to you?

How do you feel about your drawing?

BIG IDEA: Colors can be warm or cool. (C2)

GOAL: The child will use warm or cool colors in a leaf print design.

MAIN ELEMENT: Color

MATERIALS:

Assorted leaves
Tempera paints
Colored or large paper
Brush
Water bowl
Newspaper
Smock
Magazine pictures showing warm and cool effects (ex., jungles, snow scenes, night scenes, deserts, volcanoes, sunsets, fires, etc.)
Color wheel *(See next page. Paint the sections of the wheel in the appropriate color.)*

STRATEGY:

• Look at magazine pictures. Discuss how colors create a feeling of warmth or coolness.

• Look at the color wheel. Help the child identify which half is cool (green, blue, and purple) and which half is warm (red, orange, and yellow).

• Demonstrate the leaf printing technique. Choose a leaf and turn it over to the side with the prominent veins. Paint that side of the leaf and press it on to the paper.

• Arrange leaves on the paper to experiment with the idea of pattern. If desired, talk about the possibilities of overlapping the prints, or repeating a leaf shape to create the impression of movement. *(See Lesson 10.)*

WORK PERIOD:

• The child decides on a warm or cool color theme.

• The child prints with leaves. *(If the child makes a smudge, ask if it can be covered with an extra leaf print. Point out that artists generally work their mistakes into the finished project.)*

QUESTIONS FOR EVALUATION AND REVIEW:

Tell me about your leaf prints. What section do you like best? What makes that part special?

COLOR WHEEL

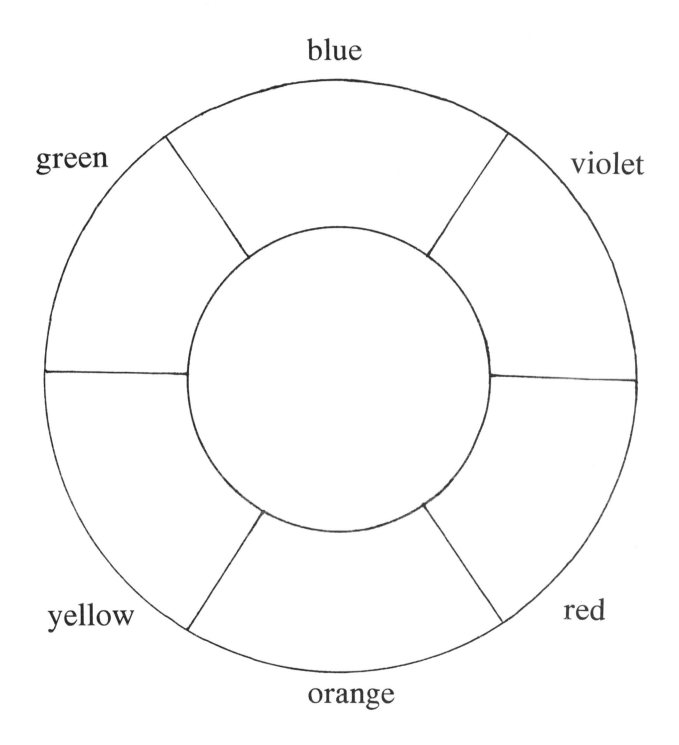

blue

green

violet

yellow

red

orange

BIG IDEA: Textures can be visual or tactile. (T3)

GOAL: The child will explore and distinguish between visual and tactile textures through crayon rubbing experiences.

MAIN ELEMENT: Texture

MATERIALS: Crayons
Paper
Objects for rubbing (ex., rubber bands, paper clips, scissors, staples, nail file, toothpicks, leaves, buttons, coins, jewelry, sandpaper, comb, shoe laces, magnetic letters)

STRATEGY:

• Look at the various objects you have collected. Explain that "texture" is the way an object feels. Use words like "bumpy", "smooth", or "rough" to describe several of the objects you have chosen.

• Demonstrate the rubbing technique by first placing an object under the paper. Feel its location with your fingertips. Rub a crayon over the object until it appears as a rubbing.

• Point out that the **object** has texture you feel with your hands (**tactile**). The **rubbing** has texture you see with your eyes (**visual**).

WORK PERIOD:

• The child chooses the objects he will print and the colors he will use.

• The child makes rubbings of different objects.

QUESTIONS FOR EVALUATION AND REVIEW:

Which textures do you like the best? What makes them interesting?

How do your textures feel? What do they look like?

25

BIG IDEA: Shapes can be repeated to suggest movement. (S1)

GOAL: The child will create the feeling of movement by using repetition in a crayon rubbing design.

MAIN ELEMENT: Shape

MATERIALS: Crayons
Paper
Manila folder or cardboard
Scissors

STRATEGY:

• Cut a simple shape (such as a square) out of a folder or index card.

• Review the rubbing technique by placing the shape under the paper. Rub a crayon over the shape until it appears as a rubbing.

• Move the shape a little, overlapping the previous shape. Rub over it again. Repeat two or three times. Point out how it looks as if the shape is moving across the page.

• Help your child decide on a shape for his design. (It could be a heart, his initial, a football- any simple shape about 2" X 2" in size.)

WORK PERIOD:

• The child draws his chosen shape on the folder or index card and cuts it out.

• The child plans the "movement" of his shape.

• The child rubs over the shape accordingly.

QUESTIONS FOR EVALUATION AND REVIEW:

What kind of movement does your rubbing have? Does it seem lively, lazy, jumpy, slow?

Show me with your hands how your shape moves.

How did you get this feeling of movement in your design? (ex., Did you repeat your shape? Overlap it?)

BIG IDEA: Color can be repeated to make patterns. (C4)

GOAL: The child will create patterns of color in a gadget printing design.

MAIN ELEMENT: Color

MATERIALS: Household gadgets (bolt, paper clip, key, ring, etc.)
Large paper
Tempera paints
Smock
2-3 paper plates
Scrap paper
Newspaper
Brush *(if desired)*
Children's blocks or colored construction paper shapes

STRATEGY:

• Look at examples of color patterns. (Some examples in the home may be clothing, wallpaper, floor tiles, or quilts.) Concentrate on the **colors** in the patterns, not the shapes.

• Make a color pattern with blocks or construction paper shapes. Ask your child to guess what color would come next. Remark that the special thing about patterns is that we know what to expect next. This is one reason why patterns feel comforting and can be found in almost every home around the world.

• Demonstrate the gadget printing technique that works best for you. (You may pour a little paint on a paper plate and dip the gadget, or you may brush paint directly on to the gadget.) Practice printing the gadget on scrap paper until you get a clear print. Then print a short pattern (ex., 1 green key, 3 red rings, etc.)

WORK PERIOD:

• Help your child decide on two or three colors for his pattern. Color themes might include all pastels, primary colors (red, yellow, and blue), cool or warm colors, or any choice that is special to your child.

• The child selects a corresponding number of gadgets and practices the printing technique on scrap paper until he can get clear prints.

• The child makes a specific pattern of prints across the page of his "good" paper.

QUESTIONS FOR EVALUATION AND REVIEW:

Tell me about the pattern you made. Do you remember what we said is special about patterns? *(We can guess what comes next.)* How do you feel about your design?

BIG IDEA: Lines can create texture and detail. (L3)

GOAL: The child uses line to create texture and detail in a styrofoam print.

MAIN ELEMENT: Line

MATERIALS:

Styrofoam meat tray
Pencil
Colored construction paper
White paper
Scrap paper
Tempera paint
Brush
Smock
Newspaper

STRATEGY:

• If possible, try to obtain pictures of linoleum prints or wood prints from books in the library. (Children's artist and author, Marcia Brown, used linoleum prints to illustrate some of her books.) As you share them with your child, point out how lines are used to create texture and detail.

• Demonstrate how a pencil can be used to carve a design into a flat piece of styrofoam tray. Brush paint on to the tray. Turn it over and print the design on paper.

WORK PERIOD:

• The child decides on a theme (such as a holiday, sports, hobby, family, animals, etc.).

• The child sketches his idea on a piece of scrap paper, including two or three different kinds of lines to create texture. (Types of line include wavy, dotted, dashed, pointed, curvy, etc.)

• The child lightly draws his design onto the styrofoam, then deepens the lines with a pencil.

• The child selects paint and paper colors and makes several prints.

QUESTIONS FOR EVALUATION AND REVIEW:

How do you like your prints?

Where are the areas that show texture?

LESSON 13, YEAR A **Splatter Stencilling** Date _____

| BIG IDEA: | Shapes can be repeated to create patterns. (S3) |

| GOAL: | The child will use shapes to create patterns in a splatter stencilling. |

| MAIN ELEMENT: | Shape |

| MATERIALS: |

Paint
Old tooth brush
Newspaper
Manila folder
Pencil
Scissors
Small paper
1-2 sheets of large paper
Smock

| STRATEGY: |

• Demonstrate the spatter stencil technique. Arrange a pattern of several squares and triangles cut from old manila folders onto a sheet of paper. Dip the tooth brush into the paint. Rub your finger over the bristles so that the paint spatters over the stencils. Make sure that there is paint all around the edge of each stencil. Carefully remove the stencils.

• Discuss the shapes your child would like to use. They may be geometric shapes, letters, animals, or shapes that symbolize a hobby or interest.

| WORK PERIOD: |

• The child traces three or more shapes on a folder and cuts them out.

• The child arranges a pattern on a large sheet of paper.

• The child splatters paint over his stencils, covering the page. (He may wish to overlap two or more colors of paint.). The child or adult carefully removes the stencils.

| QUESTIONS FOR EVALUATION AND REVIEW: |

What do you like/dislike about this project?

Tell me how you chose your shapes.

How did you make the pattern? What was repeated?

BIG IDEA: Shapes can be combined to make objects. (S2)

GOAL: The child uses various combinations of basic shapes to make objects in a sponge stamping design.

MAIN ELEMENT: Shape

MATERIALS:
Old sponges
Paint
Paper plates
Paper
Newspaper
Smock
Scrap paper
Tangram, or construction paper shapes *(See page 15.)*

STRATEGY:

• Use the pieces of the tangram or paper shapes to discover what objects can be made from them. (For example, a triangle on top of a square could be a house.)

• Point out that objects are made up of simple, smaller shapes. Identify the shapes that make up a person, a spoon, a flower, a turtle, etc.

• Cut sponges into basic shapes. Discuss ideas for making objects from the sponge shapes.

• Pour a little paint on to a paper plate. Dip a sponge shape into the paint and print it on scrap paper.

WORK PERIOD:

• Let your child try printing with the sponges on scrap paper to get the feel of the technique.

• The child decides on a theme which includes at least three objects comprised of smaller shapes.

• The child prints the objects, using the sponge shapes.

QUESTIONS FOR EVALUATION AND REVIEW:

Tell me what is happening in your painting.

What little shapes make up each object in your picture?

What shapes were hard to find?

BIG IDEA: Colors can be mixed to create new colors. (C1)

GOAL: The child will discover and create secondary colors (orange, green, and purple) and tints (pastel colors).

MAIN ELEMENT: Color

MATERIALS:

3 glasses or jars with water
3 empty glasses or jars
Tempera paint (red, yellow, blue, green, magenta, black, and white)
Food coloring
Brush
Water bowl
Paper
Newspaper
Smock
Paper plates for mixing paints
Charts *(See next two pages.)*

STRATEGY:

• Add food coloring to the water in the jars (1 yellow, 1 red, 1 blue). Mix some yellow and some red water in an empty glass. What color appears? Mix yellow and blue, then blue and red. What new colors appear?

• Fold a piece of paper in half. Open the paper and put either magenta, yellow, or blue paint on one side. Put a different color on the second side. Fold the paper in half again to mix the colors. What new color has been formed? Repeat, using different color combinations.

• Show the child the color charts. You or your child (or both of you) can paint in the circles as indicated. (Leave the unlabelled circles blank.) Explain that you will be finding out how to make new colors.

WORK PERIOD:

• Help your child follow the "directions" on the chart to mix the new colors on paper plates. Have him paint the new color on to the circle after the equal sign. If your child is old enough, have him or her write the name of the color under the circle; if not, print the name for the child. Point out that a **tint** is made when white is mixed with a color.

• If the child desires, allow him or her to make a painting which includes some of the "new" colors.

QUESTIONS FOR EVALUATION AND REVIEW:

Explain to me how you made orange, purple, and green. Show me how you made the tints. What is a tint? *(white plus a color)*

SECONDARY COLORS

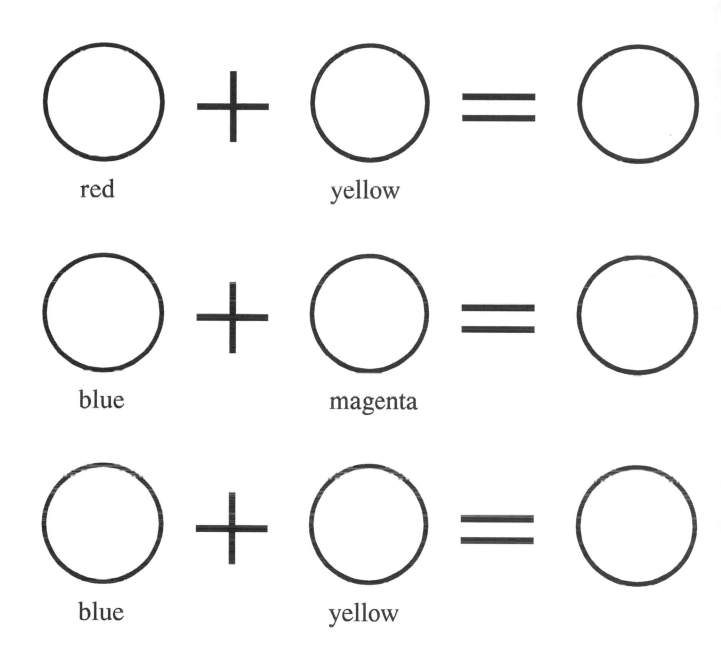

red + yellow =

blue + magenta =

blue + yellow =

TINTS

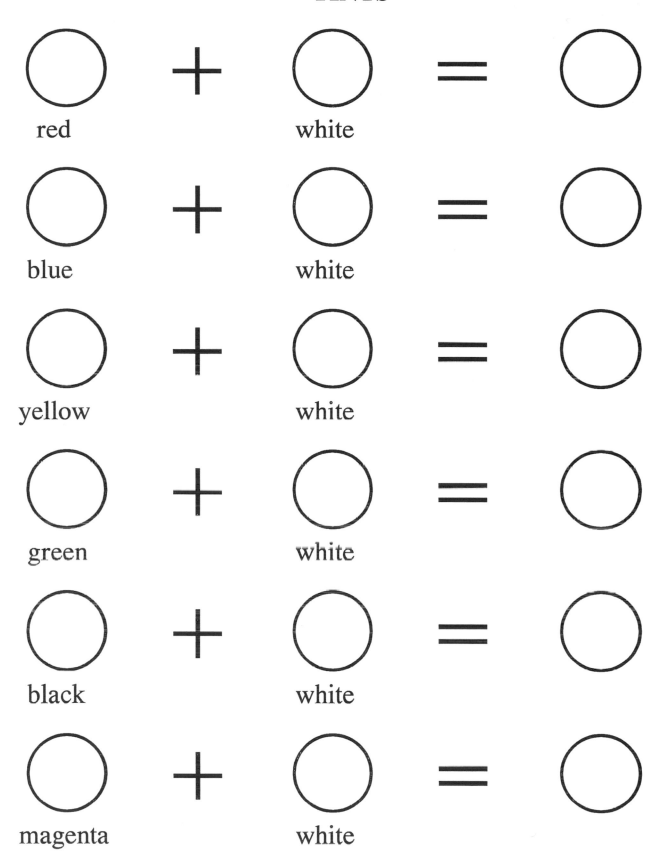

red + white =

blue + white =

yellow + white =

green + white =

black + white =

magenta + white =

BIG IDEA: Colors can be warm or cool. (C2)

GOAL: The child will use color to create a feeling of warmth or coolness in a wax resist painting.

MAIN ELEMENT: Color

MATERIALS:

Black paint
Brush
Water bowl
Paper
Newspaper
Smock
Crayons
Color wheel *(See page 23.)*

STRATEGY:

• Review the color wheel with your child. Point out the cool side (green, blue, purple) and the warm side (yellow, orange, red).

• Demonstrate the wax resist technique as follows. Choose either warm or cool colors and draw your picture, pressing hard with the crayon. When finished, paint over the drawing with thin black paint, using light, quick strokes.

WORK PERIOD:

• The child decides on a particular warm or cool scene.

• The child chooses at least three crayons in either warm or cool colors.

• The child draws a picture, then paints over the scene, as previously demonstrated.

QUESTIONS FOR EVALUATION AND REVIEW:

Tell me what's happening in your picture.

What would it feel like to be in your picture? How did you get this warm/cool feeling?

VARIATION: Instead of using black paint, use a color that goes with the cool or warm theme. For example, an underwater scene could be painted in blue, or a mountain scene could be painted in purple.

BIG IDEA: Colors can suggest a mood. (C3)

GOAL: The child will use colors that suggest a mood in a non-representational design.

MAIN ELEMENT: Color

MATERIALS:

　　　　　Tempera paint
　　　　　Brush
　　　　　Water bowl
　　　　　Paper
　　　　　Newspaper
　　　　　Smock
　　　　　Samples of non-representational art

STRATEGY:

• Look at the samples of non-representational art. (Some good artists to look for are Kandinsky, Mondrian, Pollock, and Klee.) Ask the child if these pictures look like anything he can identify. Non-representational art is not meant to look like anything; they are just designs.

• Now ask the child to look at the colors in the different pieces of art. Which colors seem happy? Sad? Angry? Excited? Calm? Scary?

WORK PERIOD:

• Help the child decide on the mood he would like to convey.

• The child chooses three colors that he feels will help him convey that mood.

• The child uses his three colors to create a non-representational design.

QUESTIONS FOR EVALUATION AND REVIEW:

Tell me about your painting.

What mood does your painting have? How did you get that mood in your painting? *(by choosing specific colors)*

How do you like your painting?

LESSON 18, YEAR A **Finger Painting** Date _____

| **BIG IDEA:** | Lines can be repeated to create rhythm. (L6) |

| **GOAL:** | The child will use repetition of line to create rhythm in a fingerpainting. |

| **MAIN ELEMENT:** | Line |

MATERIALS:

Fingerpaint or Crayola® paints
Paper
Water bowl
Newspaper
Smock
Nature items or pictures (ex., wood grains, finger prints, concentric circles
 in water, animals with stripes, feathers, leaves, bark, stones with lines)

STRATEGY:

• Examine repeating lines found in the nature items or pictures. Point out that repeating shapes create a **pattern**, but repeating lines create **rhythm**. It is called rhythm because the way the lines are repeated can give a fast or slow feeling to a piece of art.

• Let your child experiment with the fingerpainting technique. Have him try various parts of the hand- heel, fist, knuckles, side, palm, fingernails, etc.

WORK PERIOD:

• The child decides the subject of the painting.
 - If it will be a landscape, talk about the repeating lines in the grass, tree bark, sun rays, etc.
 - If it will be a person or animal, talk about the repeating lines in fabric, hair, or fur.
 - If it will be a water scene, talk about the repeating lines in the waves, shells, plants, etc.

• The child will use repeating lines in at least three areas of the fingerpainting to create rhythm.

QUESTIONS FOR EVALUATION AND REVIEW:

Tell me about your painting.

Where are the repeating lines? Do they create a slow, calm rhythm, or a fast, exciting rhythm? How did you get it that way?

What parts of your hand did you use? Which lines were made by which parts of your hand?

BIG IDEA: Lines can create texture and detail. (L3)

GOAL: The child will use line to create texture and detail in a batik painting.

MAIN ELEMENT: Line

MATERIALS:

Water colors or thin tempera paint
Brush
Water bowl
Large paper
Newspaper
Smock
Rubber cement

STRATEGY:

• Paint a large, simple shape with the rubber cement brush. Allow to dry.

• Using quick, broad strokes, paint the paper and allow to dry.

• Rub and peel off the rubber cement. Point out how the texture of the lines creates detail and interest. Tell your child that the technique of blocking out paint in certain areas is called **batik**.

WORK PERIOD:

• The child paints a line drawing in rubber cement, using large shapes.

• The child paints the entire page in various colors.

• When the paint is thoroughly dry, the child removes the rubber cement to reveal the textured lines.

QUESTIONS FOR EVALUATION AND REVIEW:

What kind of painting is this? *(batik)*

What is happening in your batik painting?

What can you tell me about the lines in your batik painting?

What parts do you like best about your batik painting?

BIG IDEA:　　Textures can be very smooth to very rough. (T2)

GOAL:　　The child will experiment with textures using a variety of paints.

MAIN ELEMENT:　　Texture

MATERIALS:　　Textured paints *(See directions in the Strategy section.)*
White tag board
Water bowl
Newspaper
Smock
Fingerpaint
Watercolor or thinned tempera paint

STRATEGY:

• If at all possible, try to visit an art gallery or store where actual paintings are sold. Many paintings will have a smooth, flat surface, but some will have very rough surfaces. (In a gallery, look for works by Pollack, Van Gogh, as well as Monet's later works.) Discuss how texture can add interest to a painting.

• Mix up some of your own textured paints by combining one ingredient from each of the following categories.
　　Pigment- food coloring, powdered herbs/spices, powdered tempera paint
　　Binder- glue, egg whites, craft gloss, liquid starch
　　Base- cornstarch, flour, salt, mud

• If desired, mix fluffy paint by combining Ivory® soap flakes with paint. Sandy paint can be made by combining sand with regular tempera paint.

WORK PERIOD:

• The child experiments with three or more textured paints. (He can also use a brush with the fingerpaint and the water colors.) Encourage the child to try different ways of applying the paint to produce different textures (ex., thin or heavy application, many or few brush strokes, etc.).

• The child creates a painting including three or more different textures. (These can be created by using different paints and/or by using different application techniques.) He might create a beach scene using the sandy paint, or a sky scene using the fluffy paint for clouds.

QUESTIONS FOR EVALUATION AND REVIEW:

Tell me about the textures in your painting. How did you make them? Which did you enjoy making the most?

Which areas of the painting are the most interesting to you?

BIG IDEA: Texture adds detail and interest. (T1)

GOAL: The child will explore how various painting tools can create different textures to add detail and interest.

MAIN ELEMENT: Texture

MATERIALS:

 Newspaper
 Paper
 Water bowl
 Smock
 Various gadgets to use as painting tools (ex., evergreen branch, yarn, marble, toy car, sponge, cotton ball, Q-tip®, old toothbrush, leaf, fork, soda straw, feather, fabric, etc.)

STRATEGY:

• Have the child separate the gadgets into two groups: one for basically smooth textures, and one for basically rough textures.

• Let the child experiment with the different tools. Encourage the child to try different techniques to create different textures, such as stroking, spattering, stamping, rolling, etc.

WORK PERIOD:

• The child paints a design using at least three different textures. (These can be created by using different painting tools and/or by using different application techniques.)

QUESTIONS FOR EVALUATION AND REVIEW:

Tell me about the textures in your painting. How did you make them?

Were you right as to which tools made which textures?

Which areas of the painting are the most interesting to you?

Which parts of your painting were the most fun for you?

BIG IDEA:	Forms have roundness. (F3)

GOAL:	The child will explore similarities and differences between two-dimensional **shapes** and three-dimensional **forms**.

MAIN ELEMENT:	Form, shape

MATERIALS:	Magazine pictures, along with the objects they represent (ex., a picture of an apple and a real apple)

Clay
Pencil
Paper
Picture of circle and square *(See next page.)*
Fork
Water bowl

STRATEGY:

• Lead a discussion about the pictures and the objects. Ask:
 How are these pairs the same? How are they different?
 Which looks more real? Why?
 Do you know what we call a flat object? *(shape)* A round object? *(form)*
 Look at each pair from the side. Do they still look the same? *(Point out that a **shape** cannot be viewed from the side because it is flat, but a **form** can be viewed from all sides because it is round.)*

• Together, look at the circle and the square on the next page. Are these **shapes** or **forms**? *(shapes)* Bring out the clay and have your child make the corresponding form for each shape. (He should make a sphere for the circle and a cube for the square. Help him with this, if necesssary.)

• Demonstrate two methods of sculpting clay.
 Pinch-and-pull method- Begin with a sphere of clay. Pull out ears and a nose; pinch in to make a mouth and eyes. Do **not** break pieces off from the lump of clay.
 Additive method- Start with a sphere, but do not use all the clay. From the remaining clay, shape ears, nose, and lips. Use the fork to roughen the surfaces which are to be stuck together. Add a small amount of water to your fingertips and moisten the places you have roughened. Then stick the pieces together tightly. (NOTE: If you simply try to stick pieces together without roughening and moistening, they will break off when the piece dries.)

• The child sculpts an object, using either the pinch-and-pull method or the additive method. (Encourage the child to turn his form as he works, since forms can be seen from all sides.)

• The child then draws his object on paper.

QUESTIONS FOR EVALUATION AND REVIEW:

Explain the difference between a **shape** and a **form**. *(A shape is flat, but a form is round.)* Which of your creations is a shape? Which is a form?

Tell me about the two ways of sculpting a form. *(Pinch-and-pull method and additive method)* Which method did you use?

Why is it important to roughen clay surfaces before you try to stick them together? *(The pieces will fall off if you don't.)*

How do you feel about your form?

BIG IDEA: Forms can be representational. (F1)

GOAL: The child will sculpt an animal using a representational ("real") style.

MAIN ELEMENT: Form, texture

MATERIALS:

Clay
Gadgets for texture *(See page 8.)*
Toothpicks
Photographs of animals (from magazines, books, calendars, etc.)
Fork
Water bowl
Paint
Brush
Mod Podge® craft gloss

STRATEGY:

• If possible, precede this lesson with a trip to see live animals at a farm, zoo, pet store, or aquarium. To stimulate thinking about this lesson, note details of each animal's anatomy (such as a pig's tail or a lion's mane) and ask how your child might be able to make those details out of clay.

• Review the two methods of sculpting from the previous lesson.

. Experiment with ways of creating texture with clay. Try using a garlic press to make tiny strings or curls. Create parallel lines with a comb, or make "fish scales" with an unsharpened pencil. Be creative!

WORK PERIOD:

• Week One- The child chooses an animal he would like to sculpt, using a photograph as a reference.

• The child then makes his animal, paying attention to realistic (representational) details and textures. (NOTE: Toothpicks can be placed inside of legs to support them.)

• Week Two- The child paints the dried form, using life-like colors and patterns. After the paint is dry, the child seals it by applying craft gloss.

QUESTIONS FOR EVALUATION AND REVIEW:

Tell me about your sculpture. What method/materials/textures/colors did you use?

Praise a characteristic of your child's work that really stood out in this lesson, such as attention to detail, patience, perseverance, creative problem-solving, diligence, etc.

BIG IDEA: Forms can be non-representational. (F1)

GOAL: The child will create a free-form (non-representational) sculpture using found objects.

MAIN ELEMENT: Form

MATERIALS:

Miscellaneous objects from around the home (ex., egg cartons, toilet
 paper tubes, buttons, string, lace, hardware, boxes, wood scraps,
 plastic caps, etc.)
Glue
Masking tape
Heavy cardboard for the base
Spray paint or single color of tempera paint and brush

STRATEGY:

• This is an excellent opportunity for a trip to a museum of modern art sculpture. If this is not possible, you can look at pictures in library books. Comment that many pieces are **non-representational**; that is, they are designs, not real things, like animals. Observe and talk about the pieces. See if your child can identify any objects within the sculptures. Point out pieces where the artist used the same color in different parts of the sculpture. (This unifies the sculpture.)

• Have your child look at the objects that have been collected. Have him use his imagination and arrange the objects in different ways to get some ideas for a sculpture.

WORK PERIOD:

• Week One- The child builds his sculpture on the heavy cardboard base. Objects can be attached to the base and to each other by using glue. Until the glue dries, tape may be used to hold the objects in place.

• Week Two- The child removes the tape supports and unifies his sculpture with a single paint color.

QUESTIONS FOR EVALUATION AND REVIEW:

In our last art lesson, we made clay animals. This time we made free-form sculptures. What do we call sculptures that look like real things? *(representational)* What do we call sculptures that do not look like real things? *(non-representational)*

Which type of sculpture do you like better? Why?

BIG IDEA: Textures can be repeated to unify a design. (T4)

GOAL: The child will create a bas relief using repeating textures to unify the design.

MAIN ELEMENT: Texture

MATERIALS:

Self-hardening clay
Plaster of Paris
Gadgets for textures *(See page 8.)*
Water (measured according to plaster directions) in a bucket
Box in which to construct the sculpture (ex., gift box, shoe box)
Old toothbrush
Paints
Mod Podge® craft gloss
Glitter *(optional)*

STRATEGY:

• Show your child some examples of **bas relief**. (Pronounce "bas" to rhyme with "pa". "Bas" is French for "low"; "relief" refers to being raised from the background.) You can visit an art museum, but you can also use coins. Have your child look at the examples and notice how the figures "stick up" from the background.

• Show your child how to create a bas relief. Press clay into the bottom of the box to create a flat layer about an inch thick. Use your gadgets to make textures in the clay.

WORK PERIOD:

• <u>Week One</u>- The child makes his own clay bas relief. Encourage him to choose two or more gadgets to work repeatedly to make a unifying pattern. When he has finished, mix the plaster in the bucket according to directions. (It works best if you sift the powder into the water until the plaster begins to form an "island" on the surface. Mix thoroughly. The plaster will be creamy!) Pour the plaster into the clay mold to a depth of two or three inches. Tap the sides of the box to loosen any air bubbles. Allow to harden for several days.

• <u>Week Two</u>- The child carefully removes the box and pulls the clay from the plaster. Brush off any remaining clay with an old toothbrush. The child paints the bas relief, adding glitter, if desired. (Encourage your child to do this in a way that emphasizes the texture pattern.) Let dry and seal with Mod Podge®.

QUESTIONS FOR EVALUATION AND REVIEW:

What do we call this kind of sculpture? *(bas relief)*

Show me where you used repeating textures. How does it make your sculpture look like one piece?

BIG IDEA: Forms can be useful (crafts). (F2)

GOAL: The child will weave a belt on a straw loom.

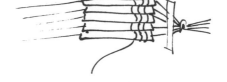

MAIN ELEMENT: Form, color

MATERIALS: 5 plastic drinking straws
Piece of heavy cardboard, approximately 5" X 7"
Tape
Yarn

STRATEGY:

• If possible, look at items that have been woven, such as rugs, articles of clothing, baskets, etc. (You can also look at samples at an art museum or craft show, or you can find pictures in books.)

• Explain that a **craft** is any art form that is useful, such as the belt you will be making today. Ask your child to name other crafts. (You may want to walk through your house to locate items that are crafts.)

• Demonstrate the weaving technique. Measure 5 pieces of yarn long enough to wrap around your child's waist, leaving extra at the ends to tie. Guide the yarn through the straws by sucking the yarn into them. Tie the strands of yarn together and tape to the cardboard, just below the knot. Slide the straws up as far as they will go. Tell the child that the yarn in the straws is called the **warp**. Tie a separate piece of yarn on to the tied end. Tell your child that this is the **weft**. Weave the weft yarn over and under the straws, going back and forth over the straws. (The straws help keep the warp yarns from getting twisted.) As the weaving grows, slide the straws down so that they are always under the weaving. When a new color is desired, cut the weft yarn and tie on a weft yarn of a new color.

WORK PERIOD:

• The child continues weaving, using two or three colors. (This will take more than one session.)

• When the weaving is finished, remove the straws and tie the warp yarn and the weft yarn together.

• Have your child try on the finished belt!

QUESTIONS FOR EVALUATION AND REVIEW:

How is a craft different from other art work? *(It is useful, or meant to be used.)*

LESSON 31, YEAR A **Sand Paintings** Date _____

Colors and shapes can be repeated to unify a design. (C5, S5)

GOAL: The child will make a sand painting using color and shape patterns to unify the design.

MAIN ELEMENT: Shape, color

MATERIALS: Jars of colored sand *(See directions below.)*
White glue
Small bowl
Water
9" X 13" pan
Paint brush
Manila folder or tagboard
Pencil

STRATEGY:

• If possible, look at samples of Native American sand paintings.

• Divide the sand into the jars. Add a few drops of food coloring and shake. Leave one jar uncolored.

• Mix glue and a little water in the bowl and demonstrate the sand painting technique. Dip the paint brush in the glue and paint a small area of a manila folder. Shake on a bit of sand, tapping off the excess over your pan. (You can then put the sand back into the jar easily.)

• Trace as large a circle as you can on a piece of manila folder. Explain to your child that he is to make a pattern of colors and shapes inside the circle. Point out that repeating colors and shapes in different parts of the circle will **unify** the work, making it look like everything belongs together.

WORK PERIOD:

• Have the child use the pencil to draw a shape in the middle of the circle. Next, he draws two alternating shapes in a ring around the central shape, forming a pattern. The child continues drawing until the circle is filled.

• The child plans the color pattern. (The child can make a small crayon mark in each shape to show what color he plans it to be.) Each ring of shapes should have its own color.

• The child paints all areas of the same color with glue and shakes on the sand. Repeat for each color.

QUESTIONS FOR EVALUATION AND REVIEW:

Point out your color and shape patterns. How do they make the painting look like everything belongs?

BIG IDEA: Texture can be repeated to unify a design. (T4)

GOAL: The child will make a pinch pot, using repeating textures to unify the design.

MAIN ELEMENT: Texture

MATERIALS:

Clay
Tempera paints
Water bowl
Paint brush
Gadgets for making textures *(See page 8.)*
Mod Podge® craft gloss
Newspaper
Smock

STRATEGY:

• Look at decorative vases and clay pots, either at home or in an art history book. Remind your child that a **craft** is art that is useful.

• Experiment with different textures by using your gadgets in a lump of clay. Have your child select two textures he would like to use in his pinch pot.

• Demonstrate making a pinch pot. Start with a ball of clay the size of your fist. Press into the middle with your thumbs and pinch the sides until they are fairly even in thickness. Continue until you have formed a bowl or pot shape.

WORK PERIOD:

• Week 1- The child forms a pinch pot. (Remind your child to keep the sides as even in thickness as possible.) The child then uses gadgets to create the two textures he has chosen, alternating them around the pot.) Explain that repeating the textures will **unify** the pot, or make it seem like one piece.

• Week 2- The child paints the pinch pot a single color. (This will emphasize the textures.) When dry, the child seals the color with craft gloss.

QUESTIONS FOR EVALUATION AND REVIEW:

How did you use texture to unify the design on your pot?

Are the sides of your pot even in thickness?

50

| **BIG IDEA:** | Shapes can be combined to make objects. (S2) |

| **GOAL:** | The child will make a shadow puppet from combined shapes. |

| **MAIN ELEMENT:** | Shape |

| **MATERIALS:** | Pre-cut manila folder or construction paper shapes
Glue
Popsicle sticks (or paint stirrers for larger puppets)
Unshaded lamp |

STRATEGY:

• Explain that shadow puppets are a popular Indonesian craft. See if you can find examples in library books.

• Experiment with making shadows of different shapes, using your hands. If your child shows interest, make more shadows with different objects. Try to guess how the shadow of a particular object will look, or look at a shadow and guess which object made the shadow.

WORK PERIOD:

• The child constructs objects (animals, people, cars, etc.) from different paper shapes and glues pieces together.

• The child glues the objects to popsicle sticks or paint stirrers (for easy handling).

• Practice making shadows with your puppets, using an unshaded lamp in a darkened room. Develop a puppet show to perform for family and/or to videotape. Consider using sound effects or music.

QUESTIONS FOR EVALUATION AND REVIEW:

How did you combine shapes to make objects?

What did you like most about making your shadow puppets?

What might you have done differently?

BIG IDEA: Shapes can be repeated to make patterns. (S3)

GOAL: The child will design and sponge a stencilled border for his room or school area.

MAIN ELEMENT: Shape, color

MATERIALS:
Manila folder
Pencil
Scissors
2 or 3 bowls
Old sponges
2 or 3 colors of paint
Long strip of paper for border (Continuous-feed printer paper works well, or you can tape regular sheets of paper together.)

STRATEGY:

• At a wallpaper or hardware store, look at some samples of borders for children's rooms.

• Discuss possible subject ideas and color schemes for your child's border. (Try to use the same colors that are in the room where the border will go.)

WORK PERIOD:

• The child draws the object that will make up the border onto the manila folder. He should use large, simple shapes, as details will not appear in this process.

• The child cuts the design from the folder. (Since the folder around the object must remain intact, some parental assistance may be required to start the cutting.)

• The child places the folder (not the cut-out object) at the beginning of his border paper. Using a separate bowl and sponge for each color, the child dabs paint over the cut-out area in the middle of the folder. The child continues to move the stencil along the paper and paint, being careful not to smear what has already been stencilled.

• Let the border dry completely, then hang.

QUESTIONS FOR EVALUATION AND REVIEW:

(Do this after the border has been hung and can be viewed in the room for which it was designed.)

Tell me about your color scheme. How do you feel about your border?

LESSON _____ , **YEAR A** **Title:** _____ **Date** _____

BIG IDEA:

GOAL:

MAIN ELEMENT:

MATERIALS:

STRATEGY:

WORK PERIOD:

QUESTIONS FOR EVALUATION AND REVIEW:

LESSON _____, YEAR A Title: _____ Date _____

BIG IDEA:

GOAL:

MAIN ELEMENT:

MATERIALS:

STRATEGY:

WORK PERIOD:

QUESTIONS FOR EVALUATION AND REVIEW:

YEAR B - PROJECTS

Unit I - Drawing

1. Still Life
2. Comic Strip I
3. Comic Strip II
4. Landscape- "Bug's Eye View"
5. Landscape- "Bird's Eye View"
6. Self Portrait I
7. Self Portrait II

Unit II - Print-Making

8. Autumn Leaf Rubbings
9. Stencilling Stationery
10. Roller Printing
11. Chalk Stencilling
12. Textile Printing
13. Fingerpaint Monoprints
14. Fingerprint Creatures

Unit III - Painting

15. Yarn Painting
16. Limited Palette
17. Mural I
18. Mural II
19. Straw Painting
20. Finger Painting with Gadgets
21. Blended Paintings

Unit IV - Sculpture

22. Edible Sculpture
23. Rock Creation
24. Popcorn Carving
25. Paper Sculpture Puppets
26. Mobiles from Found Objects
27. Clay Pinch Pots I
28. Clay Pinch Pots II

Unit V - Crafts

29. Ojo de Dios ("God's Eye")
30. Button Toy
31. Mosaic I
32. Mosaic II
33. Tie Dye
34. Woven Wall Hanging I
35. Woven Wall Hanging II

BIG IDEA: Lines can create texture and detail. (L3)

GOAL The child will draw a still life, using line to create texture and detail.

MAIN ELEMENTS: Line, texture

MATERIALS:

 Dark-colored marker (brown, blue, black, purple)
 Paper
 Objects for still life

STRATEGY:

• Search the house for textures. Together, write down as many descriptive words for textures as you can. Look at drawings which have interesting textures and talk about how the artist made the textures. (You can find art books in the library, as well as children's books that are well-illustrated. Some good children's illustrators are Garth Williams, the d'Aulaires, Maurice Sendak, and Robert Lawson.)

• Arrange a still life of objects from around the house. The objects may be tools, toys, kitchen utensils, plants, etc.

WORK PERIOD:

The child draws the still life in marker. (If the child makes a "mistake", point out that artists often turn their mistakes into part of the drawing. Help your child find a way to do this.) Encourage your child to spend a good deal of time looking at the arrangement and less time looking at the paper. Comment on his use of lines to make textures, or, if your child has worked for a long time without drawing textures, ask, "How can you add some textures to this drawing?"

QUESTIONS FOR EVALUATION AND REVIEW:

Show me the areas where you used lines to create texture.

How is drawing with a marker different from drawing with a pencil?

How do you feel about this drawing?

BIG IDEA: Lines can be used to express an idea. (L4)

GOALS: The child will use line to express an idea in a comic strip.

MAIN ELEMENT: Line

MATERIALS:

 Large drawing paper
 Pencil
 Tagboard or manila folder cut into a 4" X 4" square
 Section of the newspaper with comic strips

STRATEGY:

• Look at the comic strips in the newspaper, concentrating on those that tell a story.

• Talk about possible story ideas for the child's comic strip, such as going to the store, planting a garden, learning how to ride a bike or ice skate, or a trip to the moon. Talk about how stories have a beginning, a middle, and an end. Help your child determine the beginning, middle, and end of his comic-strip story.

WORK PERIOD:

• The child decides on a picture that would best show the beginning of his story. Then he decides on how many pictures would be needed to show the middle of the story (one, two, or three frames). Have your child describe what the last frame will look like.

• Trace the 4" X 4" square on the paper as many times as are needed for the comic strip frames.

• The child draws the comic strip. (This will take at least two sessions to complete.) As he draws, encourage him to use line to express the emotion of the character. ("Is he nervous? Scared? Excited? How can you draw that feeling on his face?") Look back at the newspaper strips for ideas.

QUESTIONS FOR EVALUATION AND REVIEW:

Tell me the story in your comic strip.

Were you able to draw the emotion(s) you were trying to show?

How do you like your comic strip?

BIG IDEA:	Large shapes emphasize an object's importance. (S4)
GOAL:	The child will emphasize an object's importance by drawing it large and up close, like a bug would see it.
MAIN ELEMENT:	Shape
MATERIALS:	Large drawing paper, taped to a piece of cardboard * Markers Beach towel Magnifying glass

STRATEGY:

If the weather permits, go outside. Stretch out on the beach towel and take a "bug's eye view" of different objects, such as a tree, a bike, a swing set, etc.). Have your child use a magnifying glass and imagine how huge these things must look to a little bug. (If the weather is inclement, you can do the same thing indoors.)

WORK PERIOD:

• Have your child choose the object that will be the main idea of his drawing.

• Have your child get as close to the object as possible to draw it. (Be sure he adds the details **around** the object, too, to make a complete scene.) Point out that, when we draw something really large, we show how important it is.

QUESTIONS FOR EVALUATION AND REVIEW:

Tell me what you like about your drawing.

What did you do about your mistakes? What would you do differently next time?

Which thing in your drawing seems the most important? Why? How did you show it was the most important?

** When your child has finished his drawing, you will need to remove it from the cardboard. If you first press the tape to your clothing to pick up a little lint before taping the paper, the paper will not stick so tightly and will remove easily without tearing.*

LESSON 5, YEAR B Landscape- "Bird's Eye View" Date _____

BIG IDEA: Lines can be repeated to create rhythm. (L6)

GOAL: The child will use repeated lines to create rhythm in a "bird's eye view" drawing.

MAIN ELEMENT: Line

MATERIALS: Drawing pad (or paper taped to cardboard, as in the previous lesson)
Pencil

STRATEGY:

• Go to a location where you will be able to look down from a height, such as a tall office building, a steep hill, balcony, etc. (If this is not possible, place several small objects on the floor and have your child stand on a chair and look down.)

• Look down, and have your child notice the small repeating lines and shapes. Have your child trace the repeated lines in the air with his finger. Remind your child that repeating shapes create a **pattern**, but repeating lines create **rhythm**. (It is called this because repeating lines can sometimes give a fast or slow feeling.)

WORK PERIOD:

• Ask your child which repeating lines he is planning to use in his drawing.

• The child draws the scene as he sees it, using repeating lines to show rhythm. Make sure your child does not concentrate on one or two objects but fills the page.

QUESTIONS FOR EVALUATION AND REVIEW:

How does the "bird's eye view" make your drawing more interesting?

Show me the repeating lines in your drawing.

How do you like your drawing?

LESSON 6, YEAR B **Self Portrait I** Date _____

BIG IDEA: Lines can create shapes. (L1)

GOAL: The child will show that lines create shapes in a self-portrait.

MAIN ELEMENT: Line, shape

MATERIALS: Pencil
Drawing paper
Mirror (preferably on a stand so the child's hands will be free)

STRATEGY:

Because this week's lesson is a pre-test, it is important to refrain from instructing your child. Next week's lesson will include helps that should make the two drawings interesting to compare.

WORK PERIOD:

The child draws his face, frequently checking the mirror for guidance.

QUESTIONS FOR EVALUATION AND REVIEW:

Tell me about your portrait. What areas were easier to draw? More difficult?

Explain to your child that this week's drawing was an experiment. Next week we'll learn more about drawing faces and draw a new portrait. It will be fun to look at both portraits and see how much you learn!

| **BIG IDEA:** | Shapes can be combined to make objects. (S2) |

| **GOAL:** | The child will carefully observe shapes within his own face. The child will also measure and observe some simple facial proportions. |

| **MAIN ELEMENT:** | Shape, line |

| **MATERIALS:** | Drawing paper
Pencil
Mirror
Measuring tape |

STRATEGY:

- Use the measuring tape on your faces and the mirror to discover some common facial measurements.
 Eyes are halfway from the chin to the top of the head.
 Heads are about 5 eyes wide.
 The corners of the mouth are straight down from the pupils.
 The nose is no wider than the inside corners of the eyes.
 The tops of the ears are at the same level as the eyes.
 The bottoms of the ears are at the same level as the "mustache area" of the face.

- Have your child practice drawing egg shapes. (This will form the head, with the point at the chin.)

WORK PERIOD:

- Have the child lightly draw a large egg shape to represent his head. Have him show with his finger where the eyes should go. If the placement is correct, tell him to make two light marks where each eye should go. Do the same with ears, mouth, and nose.

- The child now finishes the drawing by adding the details. Encourage your child to spend more time looking at the mirror than the paper, to draw what he **sees**, and not what he **thinks**. (Reliance on symbols interferes with our ability to see. A helpful technique for drawing shapes we tend to symbolize-- such as an eyeball-- is to draw all of the immediately surrounding shapes, thus creating the form of the eyeball without directly drawing it.) Hair is drawn more easily if seen as clumps and folds, which can be outlined; your child can add a few individual strands to show texture.)

QUESTIONS FOR EVALUATION AND REVIEW:

Compare the two portraits the child has drawn. What improvements do you see?

BIG IDEA: Shapes can be repeated to make patterns. (S3)

GOAL: The child will use repeated shapes to create a pattern in an autumn leaf rubbing.

MAIN ELEMENT: Shape

MATERIALS: Two leaves
One crayon (dark color)
One sheet of construction paper (lighter color)

STRATEGY:

• Collect leaves. The child selects two that have differing sizes and/or shapes.

• Discuss possible ways of creating a pattern with the leaves, such as big-little-big, smooth-jagged-smooth, etc.

• Demonstrate the rubbing technique. Place the leaf rough side up on the work surface and cover with the construction paper. Feel for the leaf through the paper and rub the crayon over the area until a print of the leaf shows on the paper.

WORK PERIOD:

The child makes his own rubbing, alternating the two leaves to create a pattern that fills the page.

QUESTIONS FOR EVALUATION AND REVIEW:

Tell me how you made your pattern.

How is your pattern the same or different from the way you imagined it?

How do you feel about your leaf rubbing?

BIG IDEA: Colors can be repeated to create patterns. (C4)

GOAL: The child will use repeated colors to create a pattern in stencilled stationery.

MAIN ELEMENT: Color

MATERIALS:
 Old sponge
 Scissors
 Paints
 Tag board, manila folder, or index card
 Several sheets of writing paper
 Smock
 Newspaper (to protect work area)
 Pencil
 A few sheets of drawing paper (for practice)
 Paper towels

STRATEGY:

• Look at samples of patterns which use repeating color. (Some possibilities include dishes, clothing, wallpaper, linens, rugs, floor tile, etc.) Concentrate on the repeating **colors**, not the shapes.

• The child decides on one special shape for his stencil- a butterfly, a heart, a football, etc.

• The child selects two colors with which he will make a pattern.

WORK PERIOD:

• The child draws his selected shape (about 2" X 2") on the tagboard. The shape needs to be cut out without disturbing the surrounding area, so an adult may need to do the cutting.

• The child practices applying paint with a sponge into the cut out area to create a stencil.

• The child stencils across the stationery, alternating colors to create a pattern. (Be sure to wipe the stencil clean with paper towels before changing colors.)

QUESTIONS FOR EVALUATION AND REVIEW:

Tell me how you created your pattern.

BIG IDEA: Lines can suggest action and movement. (L2)

GOAL: The child will use various lines to suggest action and movement in a roller printing.

MAIN ELEMENT: Line

MATERIALS:

Empty juice can
Yarn or heavy cord
Paints
Construction paper
Newspaper
Paintbrush or old sponge
Smock
Ruler *(optional)*

STRATEGY:

Early in the day (or the night before), the child glues "lines" of yarn onto all sides of the juice can. Encourage your child to try a variety of lines- curvy, straight, zigzag, spiral, dashes, etc.

WORK PERIOD:

• The child selects a paint color and several pieces of construction paper for printing.

• The child applies paint to the roller, using the paintbrush or old sponge. (The child can spread his hand inside the can to hold it, or hold the can on the end of a ruler.)

• The child prints his design by rolling the can across the paper. He can repeat his design, if desired, by using different colors of paint or starting the can at a different section.

QUESTIONS FOR EVALUATION AND REVIEW:

Tell me how you made your roller prints.

Do you see how the lines seem to move across the paper? Why do you think they look that way?

How do you like your prints?

BIG IDEA: Shapes can be repeated to make patterns. (S3)

GOAL: The child will use repeated shapes to create a pattern in a chalk stencil.

MAIN ELEMENT: Shape

MATERIALS:
Colored chalk
Tagboard, manila folder, or index card
Pencil
Scissors
Paper
Wet sponge or paper towel (for wiping fingers)

STRATEGY:

• Look at examples of patterns created by repeating shapes. (Some examples in the home may be clothing, wallpaper, floor tiles, or quilts.)

• Demonstrate the technique of chalk stencilling. Cut a shape (about 2" X 2") from a piece of tagboard. Apply chalk along the cut edges of the shape. Place the stencil on a sheet of drawing paper. Use your fingers to rub the chalk off the edges of the cut-out and onto the paper, moving away from the stencil. (Think of rays coming out from the sun.) Carefully lift the stencil and look at your shape. (You may want to show some variations of the technique, such as using more than one color of chalk on the stencil, or overlapping the stencils.)

WORK PERIOD:

• Help your child decide on two or three shapes for his pattern. (These shapes could reflect the same theme, such as different kinds of flowers, heavenly bodies, geometric shapes, sports shapes, etc.)

• The child cuts his stencils. Use tape, if needed, for any repairs.

• The child selects colors and stencils his shapes, making a pattern that fills the entire page.

QUESTIONS FOR EVALUATION AND REVIEW:

What did you do to create this pattern? *(repeated shapes)*

LESSON 12, YEAR B **Textile Printing** Date _____

Textures can be repeated to unify a design. (T4)

The child will use repeated textures to unify the design in a textile printing.

Texture

2" X 2" squares of textiles with a variety of textures (such as burlap, lace, gauze or cheesecloth, felt, velvet, tiling, cork, wood, etc.)
Paint
Paintbrush
Colored construction paper
Smock
Newspaper

• Look at your child's projects from this unit. Remark how repeating colors or shapes were used to create a pattern. Raise the idea of repeating **textures** to unify a design. Explain that repeating textures in different parts of a design makes it look like it is all one piece, like everything belongs.

• Look at the textile scraps and have your child put them in order, from very smooth to very rough.

• Demonstrate making a textile print. Apply paint to a textile square, press the square on to the paper, and peel the scrap off the paper.

• The child selects three textures to print, one paint color, and one paper color.

• The child makes prints, using all three textures in different parts of the paper. When the paper is filled, your child may wish to experiment with a different paper/paint color combination.

How did you use the three textures to **unify** your design (make it look like all one piece)? *(by repeating them)*

Are you happy with the way your design turned out?

BIG IDEA: Lines can create shapes. (L1)

GOAL: The child will use lines to create shapes in a fingerprint monoprint.

MAIN ELEMENT: Shape, line

MATERIALS:

Fingerpaints
9" X 13" pan
Newspaper
Drawing paper
Smock
Pencil
Shiny fingerpaint paper *(Freezer paper works well for this.)*

STRATEGY:

• Draw a few simple shapes on a piece of paper. As you draw, talk about how you are putting lines together to create shapes. (For example, when drawing a square, you might say, "See how I am putting these four lines together to make a square." When drawing a heart, you might say, "Here is one curved line, and here is a second. See how I put them together to make a heart?")

• Demonstrate the monoprint technique. Pour fingerpaint into the pan. (You may want to use two colors, such as blue and green, or orange and red.) Use the fingerpaint to draw a simple shape on a piece of fingerpaint paper. Place a piece of drawing paper on top of your shape. Gently pat the paper all over and pull away. (This is called "pulling a print".) Explain that this is called a **monoprint** because you can only make one copy of your picture this way.

WORK PERIOD:

The child draws some simple shapes with fingerpaint and pulls several prints.

QUESTIONS FOR EVALUATION AND REVIEW:

How did you combine lines to make these shapes?

Tell me about your monoprints. Which ones worked best? Which ones gave you trouble? What would you do differently?

Which monoprint do you like best? Why?

BIG IDEA: Lines can show various emotions. (L5)

GOAL: The child will use lines to show emotion in a fingerprint design.

MAIN ELEMENT: Line

MATERIALS:

Paint
Black fine tip marker
Paper
Comic section of the newspaper
Smock

STRATEGY:

Look at the comic section of the newspaper and discuss the variety of emotions shown. Find examples of anger, surprise, happiness, fear, embarrassment, etc. Ask questions, such as:

> How are the eyebrows drawn on the angry face?
> How is the mouth drawn on the surprised face?
> How do you know that this character is happy?

WORK PERIOD:

• The child dips his fingers into the paint and makes several fingerprints across a sheet of paper. Let dry.

• The child decides how to use lines to express different emotions on his fingerprint "faces". Let him use the marker to draw in the lines.

• The child adds finishing touches to his fingerprint creatures, such as legs, arms, feet, hats, etc. (Note: more advanced students may wish to make his fingerprints into a comic-strip story.)

QUESTIONS FOR EVALUATION AND REVIEW:

Tell me about the creatures you made. Which creature do you like best? Why?

How does each creature feel? What lines did you draw to create that feeling?

BIG IDEA: Large shapes emphasize an object's importance. (S4)

GOAL: The child will emphasize an object's importance by making it large in a yarn painting.

MAIN ELEMENT: Shape

MATERIALS:
Medium to large size drawing paper or tagboard
Pencil
Glue
Paintbrush
Water bowl
Scissors
Yarn of different colors

STRATEGY:

• Discuss how we can use **size** to emphasize an object's importance. Ask, "Does an artist use a small shape or a large one when he wants to show something is important?"

• Help your child choose an object he wants to emphasize. It should be an object that has large, simple, colorful parts, such as a flower, a pineapple, a toy, etc.

WORK PERIOD:

• The child makes a large sketch of his object, filling the page.

• The child then paints glue into an area and fills the area with yarn, either coiling from the inside out or from the outside in. Continue working until the object is completely "painted" in yarn. (If this seems too tedious for your child, he can simply outline the shape with yarn and paint the inside with regular tempera paints.)

QUESTIONS FOR EVALUATION AND REVIEW:

Were you able to show that your object is important? How?

How do you feel about your results?

LESSON 16, YEAR B **Limited Palette** Date _____

BIG IDEA:	Colors can suggest a mood. (C3)

GOAL:	The child will explore ways in which color suggests a mood in a crayon painting.

MAIN ELEMENT:	Color

MATERIALS:	Paper
	Selected crayons or oil pastels

STRATEGY:

• Find samples of pictures that use a limited palette; that is, the picture is done in only certain colors. Many of the Impressionists (Monet, Manet, Degas, Renoir) limited their pictures to a pastel palette. Mondrian is known for his use of primary color schemes, and Rembrandt is known for his dark colors. Georgia O'Keefe did beautiful work in both warm and cool palettes, as well as pastels.

• Talk about the limited palettes in the samples. What mood or feeling is created? (Examples: pastels can give a dreamy feeling; bold primary colors often create excitement; dark colors could suggest sadness.)

WORK PERIOD:

• The child decides on a mood he would like to express in a picture and selects the color scheme he feels will best express this mood. He then puts away the crayons he will not be using.

• The child decides on the subject for his picture and draws it. (NOTE: The child may also choose to make a non-representational picture; that is, it may be a design, rather than a real object. This is perfectly acceptable.)

QUESTIONS FOR EVALUATION AND REVIEW:

What mood does your picture express? How did you create that mood? *(by only choosing certain colors)*

What do you like about your work today?

LESSONS 17 & 18, YEAR B **Mural** Date _____

BIG IDEA:	Colors can be warm or cool. (C2)

GOAL: The child will explore how colors can create a warm or cool effect in a mural painting.

MAIN ELEMENT: Color

MATERIALS:

Thick paints
Brush
Water bowl
Large paper
Newspaper
Smock
Pencil
Color wheel *(See page 23.)*
Rags or paper towels
Tape

STRATEGY:

• Look at the color wheel. Which colors seem warm? *(red, orange, yellow)* Which colors seem cool? *(purple, blue, green)*

• Think of several situations or scenes which could be painted in only warm or only cool colors.

• Tell the child that he will be painting a **mural**. "Mural" comes from the French word, "mur", which means "wall". This is because a mural is a picture painted on the wall. Tape the large paper to the wall. Draw a 1" border on each side so the child can paint up to the border and not get paint on the wall.

WORK PERIOD:

• Week One- The child chooses an idea for a warm or cool scene and thinks of five or more objects to be included in the mural. The child lightly sketches the scene in pencil. All objects should be large.

• Week Two- Arrange newspaper on the floor under the mural. Instruct your child to paint to the border (not to the paper's edge). Let your child paint his mural. If paint runs, give him a rag or paper towel to blot up the excess.

QUESTIONS FOR EVALUATION AND REVIEW:

Were you able to create the warm or cool effect that you wanted? How did you do it?

What is happening in your mural?

LESSON 19, YEAR B **Straw Painting** Date _____

BIG IDEA: Lines can be repeated to create rhythm. (L6)

GOAL: The child will use repeated lines to create rhythm in a straw painting.

MAIN ELEMENT: Line

MATERIALS: Tempera paint, thinned with water
Brush
Water bowl
Paper
Newspaper
Smock
Straw

STRATEGY:

• Demonstrate the straw painting technique. Use the brush to put a small puddle of paint on the paper. Use the straw to blow the paint into lines of color.

• Observe that the repeating lines have a feeling of rhythm. Discuss with your child what the lines resemble. (A tree? A sea urchin? A porcupine? A pincushion?)

WORK PERIOD:

• Let your child experiment with this technique. Make sure your child breathes in as deeply as he breathes out to avoid hyperventilation. (If your child should feel light-headed, have him breathe into a paper bag for a few minutes.)

• The child uses a variety of colors and fills an entire page.

QUESTIONS FOR EVALUATION AND REVIEW:

Look at the rhythm of your painting. Clap the rhythm that your picture suggests.

How do you like the look you get with straw painting?

BIG IDEA: Texture adds detail and interest. (T1)

GOAL: The child will use gadgets to add detail and interest in a fingerpainting design.

MAIN ELEMENT: Texture

MATERIALS:

> Fingerpaints
> Fingerpainting paper (or freezer paper)
> Newspaper
> Smock
> Water bowl
> Tape
> Gadgets for creating texture (Q-tip, hair curler, sponge, potato masher, wadded-up ball of paper, leaves)

STRATEGY:

• Tape down and moisten the fingerpaint paper. Demonstrate creating a smooth, even layer of color with your hands.

• Press two or three objects into the paint and lift them off. The objects will remove some of the paint and create a textured look.

WORK PERIOD:

• Let your child decide on two or three colors of paint and spread them out evenly to cover the surface of his paper.

• Have the child wash and dry his hands.

• The child decides on the textures he wants and makes them all over his paper.

QUESTIONS FOR EVALUATION AND REVIEW:

Do textures help to make your fingerpainting more interesting?

What would your design be like without so many textures filling the page?

How do you like your design?

BIG IDEA: Textures can be repeated to unify a design. (T4)

GOAL: The child will use repeated texture to unify a painting.

MAIN ELEMENT: Texture

MATERIALS:
Oil pastels or crayons
Paper
Pencil eraser

STRATEGY:

• Get examples of Impressionist art from the library. (Some artists to look for are Monet, Manet, Degas, and Renoir.) Look at the soft, blended colors. Remark that this art was called "Impressionism" because many times details weren't really drawn; you only got the impression that they were there. (This style was so different at the time that it shocked many people. Some people said it was "smudgy".)

• Demonstrate the blending technique. Draw an object with the crayons, then rub the pencil eraser all over the picture to blend the colors. (This will create an Impressionistic effect.) Comment that having this blended texture all over the picture makes everything in the picture looks like it belongs together.

WORK PERIOD:

• The child selects a scene like the ones the Impressionists painted, such as ballet dancers or horses (like Degas), children (like Cassatt), or a lily pond (like Monet)

• The child draws the scene, filling the entire page. He then rubs the eraser over the page to make the blended texture.

QUESTIONS FOR EVALUATION AND REVIEW:

How did you get the soft, blended texture in your painting?

How would the picture look if you blended some parts and did not blend others? Would it look like everything belonged? *(No)*

What did people call this style of painting? *(Impressionism)* Did everyone like it at first? *(No)*

BIG IDEA: Forms have roundness. (F3)

GOAL: The child will observe that forms have roundness while making an edible sculpture.

MAIN ELEMENT: Form

MATERIALS: Edible playdough *(Mix 1 c. peanut butter, 1 c. corn syrup, 1½ c. powdered milk, and 1¼ c. powdered sugar.)*
"Decorations" (raisins, dried fruit, coconut, cocoa powder, mini-marshmallows, chocolate chips, candies, etc.)

STRATEGY:

• Review with your child the concept of **form**. Remind him that a form can be viewed from all sides and, therefore, has roundness.

• Talk about some things your child might want to make with the edible playdough. Talk about the "decorations" he might use in completing his sculpture.

WORK PERIOD:

• Have your child wash hands before beginning his project.

• The child experiments making different forms with the edible playdough.

QUESTIONS FOR EVALUATION AND REVIEW:

How do you like your forms?

Which form do you like best? Why?

Why do we have to plan all sides when making a form? *(because forms have roundness)*

How do your forms taste? *(Allow eating only after the evaluation has been completed!)*

BIG IDEA: Colors can be mixed to create new colors. (C1)

GOAL: The child will mix colors for a rock creation sculpture.

MAIN ELEMENT: Color

MATERIALS:
 Paints (red, yellow, blue, green, magenta, black, and white)
 Brush
 Water bowl
 Newspaper
 Smock
 Mod Podge® craft gloss
 Googly eyes and felt, purchased from a craft store *(optional)*
 Paper plates (for mixing colors)
 Several large, clean, dry rocks

STRATEGY:

• Look with your child at the different rocks. Does any one in particular suggest something to your child (such as a turtle, a building, a car)? Help your child select the rock he will use and what it will look like.

• Talk about the colors he would use to paint the rock. When he mentions a color you do not have (such as brown), point out that you do not have that color of paint, but it is possible to **make** the color he desires.

WORK PERIOD:

• The child mixes the colors he wants on paper plates and paints his creation. (This can be an experimental time for you and your child, but you will want to have some general ideas about the colors that can be created. Adding white to a color creates a pastel, or a **tint**. Adding black to a color produces a **shade**. White + red + a dab of green create a flesh tone. Red + blue + yellow create brown. Let your child have fun creating new colors, but remind him of his main goal-- painting the rock creature.) Remind your child to paint all sides of the creation, because forms have roundness.

• After the paint has dried, the child applies craft gloss to seal the colors. Googly eyes and felt "feet" or "hands" may be glued on, if desired.

QUESTIONS FOR EVALUATION AND REVIEW:

Which colors did you enjoy making the most? Did the colors turn out the way you expected?

Why did you paint all sides of your creation? *(because forms have roundness)*

| BIG IDEA: | Forms can be representational. (F1) |

| GOAL: | The child will carve a representational form from a ball of clay. |

| MAIN ELEMENT: | Form |

| MATERIALS: | Clay |

Clay
Carving tools (nut pick, baby spoon, table knife, etc.)
One sheet of dark construction paper
Popcorn
Magnifying glass *(optional)*

STRATEGY:

• Give your child a ball of clay as big as his fist. Allow him to experiment with the carving tools.

• Give your child a handful of popcorn. Have him spread the pieces over the dark paper and examine them under the magnifying glass. He is to choose the single piece of popcorn he finds the most interesting.

WORK PERIOD:

The child digs, scrapes, and carves the ball of clay to make it look like the piece of popcorn he chose. Tell him he is making a "giant piece of popcorn". Encourage your child to turn both the piece of popcorn and the ball of clay as he works. (Remind him that this is because he is making a **form**. Forms have roundness and can be viewed from all sides.)

QUESTIONS FOR EVALUATION AND REVIEW:

How did you like carving? What was easy, and what was hard? Were some tools easier to use than others? Which were better for carving small pieces? Large ones?

Did you need to look carefully at the popcorn to know where to carve?

How do you feel about your giant popcorn?

BIG IDEA: Forms can be useful (decorative). (F2)

GOAL: The child will use paper sculpture forms to decorate a puppet.

MAIN ELEMENT: Form

MATERIALS:

Construction paper in various colors
Glue
Scissors
Paper lunch bag
Pencil (for curling, not drawing!)
Hole punch

STRATEGY:

• Explore making simple forms with the scissors and paper. (Some ideas to try: fold a strip back and forth like an accordion, cut a circle into a strip to create a spiral, curl a strip of paper on the pencil, cut fringes, glue a cylinder, make "polka dots" or crescents with a hole punch.)

• Discuss the puppet your child is going to make. Does he want to make an animal? A person? An imaginary creature?

WORK PERIOD:

The child creates his puppet, using the paper bag as a base and adding some of the different forms he explored.

QUESTIONS FOR EVALUATION AND REVIEW:

Tell me about the forms you made. How did you make them?

How do you feel about your puppet?

BIG IDEA: Forms can be non-representational. (F1)

GOAL: The child will construct a non-representational mobile.

MAIN ELEMENT: Form

MATERIALS: Found objects (small boxes, pipe cleaners, lids, egg carton cups, cardboard tubes, etc.)
Yarn or string
Scissors
Circular lid to a plastic container
Hole punch
Paints *(optional)*

STRATEGY:

• If possible, visit a museum that has a mobile, or look at mobiles in an art book or baby store. Introduce the term, "mobile", which means "moving". Ask the child why he thinks this art form is called a mobile.

• Prepare the holding piece by cutting the center out of the plastic lid. (This should leave a piece looking like a large ring or hoop.) Punch two holes in the plastic lid on opposite sides and tie a piece of yarn (12"-15") to connect the holes. (The yarn should not be taut.) Halfway between the holes, punch a third hole. Punch a fourth hole on the opposite side. Tie another piece of yarn (the same length as the first) to connect these two holes. Tie a long piece of yarn to the place where the two pieces of yarn cross so that you can suspend the mobile from the ceiling.

WORK PERIOD:

• The child chooses the objects he wants in his mobile. He can paint these, if desired.

• Attach a piece of yarn to each object. (You may need to help with this.) Have the child tie the objects to the holding piece in different locations. Move objects around the circle as needed to achieve balance.

• As your child works, point out the difference between this mobile and the rock sculpture the child made earlier in this unit. The rock sculpture was made to look like something, but a mobile does not. Therefore, the rock sculpture was **representational**, but the mobile is **non-representational**.

QUESTIONS FOR EVALUATION AND REVIEW:

How did you get your mobile to balance when some objects are heavy and some are light? *(moved them)*

Why do we call this mobile "non-representational"? *(It doesn't look like anything.)*

BIG IDEA: Forms can be useful. (F2)

GOAL: The child will form a clay pinch pot.

MAIN ELEMENT: Form

MATERIALS: Self-hardening clay

STRATEGY:

Look at pots in an art history book, or visit a museum, art gallery, ceramics studio, craft store, or plant store.

WORK PERIOD:

• The child kneads the clay several times to remove any air bubbles and to make it more workable. He then rolls it into a ball about the size of his fist.

• The child "opens" the ball by pressing a thumb into the center and then pinching around until the clay is bowl-shaped.

• The child continues forming the sides of the pot until they are fairly uniform in thickness.

QUESTIONS FOR EVALUATION AND REVIEW:

Look at the pinch pot from all sides. (Remember, it's a form!) Look for any areas that need improvement and make any necessary adjustments.

Forms can be useful. How will you use your pinch pot when it is finished?

BIG IDEA: Colors can be repeated to create patterns. (C4)

GOAL: The child will use repeating colors to create a pattern on a clay pinch pot.

MAIN ELEMENT: Color

MATERIALS:

Paint
Mod Podge® craft gloss
Newspaper
Brush
Cotton swabs
Water bowl
Smock
Scratch paper

STRATEGY:

The child selects three colors to repeat in a pattern for last week's pinch pot. Let him experiment with different lines on the scratch paper. (Cotton swabs make neat and easy polka dots.)

WORK PERIOD:

• The child paints his pattern on to the pinch pot.

• When the paint is dry, the child applies a coat of craft gloss to seal the colors. (Apply the gloss inside the pot, too, to protect the clay from moisture.)

QUESTIONS FOR EVALUATION AND REVIEW:

(Wait until the craft gloss is clear and dry.)

Tell me about the colors you chose for your pattern.

Look at the pinch pot from all sides. Is the color pattern repeated all over the form?

How will you use your pinch pot?

LESSON 29, YEAR B Ojo de Dios ("God's Eye") Date _____

BIG IDEA:	Colors can be repeated to create patterns. (C4)

GOAL: The child will use repeating colors to create a pattern in an Ojo de Dios design.

MAIN ELEMENT: Color

MATERIALS: 2 sticks or dowels (each about 10" long)
3 colors of yarn
Glue

STRATEGY:

• Try to find some samples of Mexican weaving, pottery, or jewelry (or look at pictures of these in library books). Look at the samples and point out the bright, colorful patterns that are used. Notice how the colors are repeated to make the patterns.

• Tell your child that he will be making a design that is called, "Ojo de Dios" (pronounced "O-ho day dee-OS), which means "God's eye" in Spanish.

• Demonstrate the technique. Using the first color of yarn, tie the two sticks together at their middles to create a cross shape. Secure the knot with a dab of glue. Begin weaving by wrapping the yarn over and around one stick, over and around the second, etc. When you come back to the first stick, continue weaving next to the first strand. As the design builds, it will form a diamond shape on the four sticks.

WORK PERIOD:

The child selects three colors of yarn and begins to weave. When it is time to change colors, the next yarn color is tied onto the last one. (The child may need some adult assistance here.) Repeat the colors to make a pattern (at least two times or more).

QUESTIONS FOR EVALUATION AND REVIEW:

What do you think about the pattern your colors made? Did it come out the way you expected?

How did you choose those colors?

Where would you like to hang your project?

BIG IDEA: Colors can be mixed to make new colors. (C1)

GOAL: The child will combine colors to make new colors in a button toy.

MAIN ELEMENT: Color

MATERIALS:
Large button or round disk, made of cardboard or wood (about 4" in diameter) with two buttonholes
3 feet of nylon cord
Markers
Sample button toy, previously made, but with no colors yet

STRATEGY:

• Remind the child of his rock sculpture from the previous unit. Does he remember how he made new colors? Explain that this button toy project mixes colors in a different way.

• Demonstrate using the button toy. Thread the cord through both holes of the button and tie the free ends together to make a giant loop. Wind up the cord by holding an end of the loop in each hand; loop the button around and around. Pull the cord out and in, like playing an accordion. The button will spin as the cord winds and unwinds. (You can explain to your child that this is a very old toy that children played with long ago.)

WORK PERIOD:

• The child selects two colors for one side of the button and two for the other side. Then the child colors the button with the markers, making an interesting pattern on both sides.

• Help your child loop the cord through the button and wind it up. Have him observe what happens to the two colors on each side of the button. *(Because the colors are spinning so fast, your eye will blend the two colors into a new one.)*

QUESTIONS FOR EVALUATION AND REVIEW:

Show me how your button toy works.

What colors did you use on each side? What happened to the two colors? How did the toy mix the new colors?

LESSONS 31 & 32, YEAR B **Mosiac** Date _____

| BIG IDEA: | Shapes can be combined to make objects. (S2) |

| GOAL: | The child will combine shapes to make objects in a mosaic. |

| MAIN ELEMENT: | Shape |

| MATERIALS: |

Tagboard or manila folder
White glue on a small plate
Small squares of cut construction paper
Pencil

| STRATEGY: |

• If possible, find samples of mosaics in a muscum, art gallery, or library book. Point out that the larger objects were made by combining many small shapes.

• Demonstrate the technique. Lightly draw a simple object, like an apple, about 3" high. Dab glue into the apple with your fingertip and apply cut paper squares (yellow, red, or green) to fill the area.

| WORK PERIOD: |

• Week One- The child decides on a theme for a mosaic and lightly draws the objects on to the tagboard. (NOTE: Large, simple objects work best.) The child then proceeds to fill in the mosaic, object by object.

• Week Two- The child finishes the mosaic by filling in the background with colored paper squares. (He may also want to add a border in a different color of paper squares to "frame" the design.)

| QUESTIONS FOR EVALUATION AND REVIEW: |

How did all these little shapes become a big picture?

How did you feel about this project? *(Remember, it is fine if your child does not prefer this kind of craft. Some children will find the repetition to be relaxing, while others will find it tedious. This can be an important clue in determining your child's learning style and later career satisfaction.)*

BIG IDEA: Lines can be repeated to create rhythm. (L6)

GOAL: The child will use repeated lines to create rhythm in a tie die design.

MAIN ELEMENT: Line

MATERIALS: Fabric dye, prepared in a bucket according to package directions
Cotton tee shirt
Rubber bands (at least 1 dozen)
Large fabric scrap (about 12" square)
Smock

STRATEGY:

• Demonstrate the technique using the fabric scrap. First, pinch the fabric at the center and, holding it by the pinched piece, allow the rest to flow down. Twist the pinched piece slightly and wrap a rubber band around it, about a half-inch down. Add a second band about 1" below the first, and a third about 1" below the second. (You are working your way from the center to the edges of the fabric scrap.)

• Discuss the concept that, while repeating shapes create **patterns**, repeating lines create **rhythm**. (It is called rhythm because it can give a fast or slow feeling.) You are going to create repeated lines where the rubber bands are on the fabric. This will give the whole piece a feeling of rhythm.

• Dip the scrap into fabric dye and rinse according to the package directions. Remove the rubber bands and see the design that has been created.

WORK PERIOD:

• The child pinches different sections of his tee shirt, wrapping rubber bands around each section. (Don't forget the sleeves!)

• The child dips his shirt in the fabric dye, rinses, and removes the rubber bands to view the design.

QUESTIONS FOR EVALUATION AND REVIEW:

(Wait until the shirt has been washed and dried.)

Where are the repeating lines in your tee shirt? Do they give the design a feeling of rhythm?

LESSONS 34 & 35, YEAR B **Woven Wall Hanging** Date _____

BIG IDEA: Textures can be repeated to unify a design. (T4)

GOAL: The child will use repeating textures to unify a woven wall hanging.

MAIN ELEMENT: Texture

MATERIALS: Weaving materials (yarn, aluminum foil, fabric strips, crepe paper
 streamers, strips of cellophane, cord, etc.)
 5 drinking straws
 Scissors
 Masking tape

STRATEGY:

• Look at examples of weaving in your home (rag rugs, baskets, etc.) or in a craft store or library book.

• Look at the different weaving materials and discuss their different textures. Explain that repeating different textures in a design **unifies** it, or makes it look like all one piece. Have your child make sure all of the weaving material is in a "rope" form; this means that materials such as aluminum foil or crepe paper will need to be twisted to look like ropes.

• Demonstrate the weaving technique. Measure and cut 5 pieces of yarn (same color) to be about 18" in length. Guide the yarn through the straws by sucking the yarn into them. Tie the strands of yarn together and tape to the table, just below the knot. Slide the straws up as far as they will go. Tell the child that the yarn in the straws is called the **warp**. Tie a piece of weaving material on to the tied end. Tell your child that this is the **weft**. Weave the weft over and under the straws, going back and forth over the straws. As the weaving grows, slide the straws down so that they are always under the weaving. When a new weft is desired, cut the old weft and tie a new weft to it.

WORK PERIOD:

The child selects three textures and weaves them as demonstrated. Encourage him to repeat the textures throughout the piece. It will probably take two sessions to weave to the desired length (8" - 12"). When finished, tie the weft and the warp yarns together and cut off any excess.

QUESTIONS FOR EVALUATION AND REVIEW:

Show me the different textures you used. How do they make the design look like one piece? *(by repeating)*

Where would you like to hang this? *(NOTE: When hanging artwork, the general rule is to hang it so that the center of the piece is at eye level-- lower in children's areas.)*

LESSON _____, YEAR B Title: _____ Date _____

BIG IDEA:

GOAL:

MAIN ELEMENT:

MATERIALS:

STRATEGY:

WORK PERIOD:

QUESTIONS FOR EVALUATION AND REVIEW:

LESSON _____, YEAR B Title: _____ Date _____

BIG IDEA:

GOAL:

MAIN ELEMENT:

MATERIALS:

STRATEGY:

WORK PERIOD:

QUESTIONS FOR EVALUATION AND REVIEW:

LESSON _____, YEAR B Title: _____ Date _____

BIG IDEA:

GOAL:

MAIN ELEMENT:

MATERIALS:

STRATEGY:

WORK PERIOD:

QUESTIONS FOR EVALUATION AND REVIEW:

YEAR C - PROJECTS

Unit I - Drawing

1. Blind Contour Drawings
2. Modified Blind Contour
3. City Scape
4. Still Life I
5. Still Life II
6. Portraits
7. Nature Study

Unit II - Print-Making

8. Fabric Leaf Prints
9. Clay Printing
10. Glue Printing
11. Vegetable and Fruit Prints
12. Drip Prints
13. Wood Block Printing
14. String Pulls

Unit III - Painting

15. Cut Paper Collage
16. Wet Chalk
17. Painting a la Mondrian
18. Still Life I
19. Still Life II
20. Full Body Self-Portrait I
21. Full Body Self-Portrait II

Unit IV - Sculpture

22. Papier Mâché I
23. Papier Mâché II
24. Papier Mâché III
25. Foil and Ink Bas Relief I
26. Foil and Ink Bas Relief II
27. Clay Forms I
28. Clay Forms II

Unit V - Crafts

29. Fabric Paint Shirt
30. Diorama I
31. Diorama II
32. Papier Mâché Container I
33. Papier Mâché Container II
34. Paris Craft® Finger Puppets I
35. Paris Craft® Finger Puppets II

BIG IDEA: Lines can create shapes. (L1)

GOAL The child will use line to create shapes in a blind contour drawing.

MAIN ELEMENTS: Line

MATERIALS: Dark-colored marker (brown, blue, black, purple)
White paper (the larger the better)
Interesting objects to draw (sports equipment, dolls, tools, kitchen utensils, shoes, etc.)

STRATEGY:

• To review the concept that lines create shapes, play "What Is It?" Think of a common shape (such as a square, a heart, etc.). Draw one line of the shape and have your child guess what it is going to be. Draw a second line and let the child guess again. Continue until the shape is finished.

• Discuss the technique of "blind contour"-- drawing a picture while only looking at the object. (**No** peeking at the paper!) Explain that drawings are very interesting when made this way and that careful **seeing** will make your child become a better artist.

• Now actually demonstrate the technique yourself by doing a blind contour drawing of your hand. Take your time-- and don't cheat!

WORK PERIOD:

The child chooses an object to draw and does a blind contour drawing. Remind him to draw slowly and carefully, looking at the object he is drawing.

QUESTIONS FOR EVALUATION AND REVIEW:

(Blind contour drawings are unusual and have beautifully sensitive lines. Help your child appreciate this different look by pointing out these special qualities.)

Show me the shapes your lines made. (Remember, a shape can be any enclosed area.)

Did you need to look more carefully at the object when you were drawing this way?

Do the lines in the blind contour drawing look different from the lines you usually draw?

BIG IDEA: Lines can be repeated to create rhythm. (L6)

GOALS: The child will use repeated lines to create rhythm in a modified blind contour drawing.

MAIN ELEMENT: Line

MATERIALS:

Large drawing paper
Dark marker
Interesting objects to draw

STRATEGY:

Look at last week's blind contour drawing. Discuss the idea that good drawings happen when there is careful **seeing**. This week your child will do another contour drawing, but will be allowed to glance at his paper (but only in order to determine proper placement).

WORK PERIOD:

The child draws slowly and carefully, spending almost all of the time looking at the object. Encourage your child to pay close attention to detail. For any areas that are fluffy, bunchy, shaggy, or rough, have your child repeat lines. (This will create a feeling of rhythm.)

QUESTIONS FOR EVALUATION AND REVIEW:

How do you feel about this drawing?

Which drawing do you like better-- last week's, or this week's? Why?

Show me where you repeated lines. Do they give your drawing a feeling of rhythm?

How do you feel about drawing without looking at your paper?

LESSON 3, YEAR C **City Scape** Date _____

BIG IDEA: Shapes can be repeated to unify a design. (S5)

GOALS: The child will use repeated shapes to unify a city scape drawing.

MAIN ELEMENT: Shape

MATERIALS: Drawing paper
Dark marker

STRATEGY:

• Find an interesting place to draw-- perhaps the downtown area, a harbor, a shopping center, a park, a row of stores or houses. (Although the title of this lesson is "City Scape", and cities have many interesting places to draw, your child can draw whatever area he lives in.)

• Talk about how repeating shapes can unify a design. (This means that having the same shape appear in different parts of the drawing makes everything look like it belongs in the same picture.) Help your child identify the repeating shapes in the area he wishes to draw, such as the box shapes of buildings, the triangle shapes of sails, the round shapes of trees, etc.

WORK PERIOD:

• The child chooses a view that he thinks will make an exciting drawing, as well as one which has repeating shapes.

• The child draws the city scape, making large shapes that will fill the paper.

QUESTIONS FOR EVALUATION AND REVIEW:

Show me your repeating shapes. Do those repeating shapes help to unify your picture?

How do you like your work?

BIG IDEA: Lines can create shapes. (L1)

GOAL: The child will use lines to create shapes in a still life drawing.

MAIN ELEMENT: Line, shape

MATERIALS: Drawing paper
Markers or crayons
Magazine picture *or* arranged objects, placed where they will not be
disturbed until the next art session

STRATEGY:

• Look through magazine pictures for samples of still life. (Pictures of people are **portraits**; outdoor views are **landscapes**; pictures of objects are **still life**.)

• Help your child select a still life he would like to draw, or help him arrange objects for his own still life. (Some objects that lend themselves well to still life are boxes, hats, art supplies, musical instruments, simple machines, collections, science equipment, and toys.)

WORK PERIOD:

• Have your child look at the still life. Have him look at each object in the still life to determine its basic shape (outline). If necessary, have him draw the shape of the object in the air with his finger.

• The child draws the still life, concentrating on the lines that create the shape of each object. Encourage him to draw slowly (so that he can really **see**) and to make large shapes so that he can fill the page.

(Your child should be encouraged to take his time and use two art sessions to complete his drawing. However, some children will complete their drawings in one session. If your child completes the drawing in one session, use a different still life for Lesson 5.)

QUESTIONS FOR EVALUATION AND REVIEW:

Tell me what you like about your drawing.

Show me areas where lines make shapes (a shape being any enclosed area).

BIG IDEA:　　　Lines can create texture and detail. (L3)

GOAL:　　　The child will use lines to create texture and detail in a still life drawing.

MAIN ELEMENT:　　　Line, texture

MATERIALS:　　　Drawing paper
　　　　　　Markers or crayons
　　　　　　Magazine picture *or* objects arranged into a still life

STRATEGY:

Carefully take your child's picture from last week and tape it to a wall, using loops of tape on the back of the drawing so as not to ruin the paper. (The drawing should be at the child's eye level when he is seated near it.) Discuss the drawing together. What details are missing? What areas are not very interesting? Would they benefit by adding lines to show a texture or a pattern? Would adding a background color or border make the picture more interesting?

WORK PERIOD:

The child adds the finishing touches to his drawing.

QUESTIONS FOR EVALUATION AND REVIEW:

Tape the finished drawing to the wall.

How do you feel about your still life drawing now? Did your additions help make it more interesting?

Show me areas where you added details or textures. What lines did you use to do that?

Where are your favorite areas of the drawing?

97

BIG IDEA: Lines can show various emotions. (L5)

GOAL: The child will use lines to show emotion in a portrait.

MAIN ELEMENT: Line

MATERIALS:
Crayons
Drawing paper
Photo or magazine picture of a person to draw

STRATEGY:

• Draw a happy face (or make one using your own face) and ask your child to identify the emotion. Then ask him what line(s) on the face show that emotion. Do the same thing with a sad face and an angry face. Explain that lines can be used to show emotions.

• Look through photos or magazines for pictures of people's faces that show emotion. Have your child trace with his finger over the lines that show the emotion.

• Have your child select a picture of a person who is showing a particular emotion. See if he can identify lines that show that emotion.

WORK PERIOD:

The child draws the portrait, using lines to show emotion. (Encourage your child to have the portrait fill the entire page.)

QUESTIONS FOR EVALUATION AND REVIEW:

Tell me about your portrait.

What lines did you use to show how the person is feeling?

BIG IDEA: Lines can create texture and detail. (L3)

GOAL: The child will use lines to create texture and detail in a nature study.

MAIN ELEMENT: Line, texture

MATERIALS:
Drawing paper
Crayons or markers
Plant or animal

STRATEGY:

• You may wish to plan a field trip to provide motivation for this project. Some ideas include a zoo, a farm, an aquarium, an arboretum, a garden, a pet store, a greenhouse, or a friend's home to view an unusual pet. (If a field trip is not possible, look at science magazines, encyclopedias, or library books to find pictures of interesting plants and animals.) This project may also be tied into a science project or report that is part of your child's regular studies.

• Help your child select a plant or animal he would like to draw. (NOTE: Drawing a moving animal might be too frustrating for your child. You may want to suggest switching to a more "cooperative" creature, such as a plant or tree.) Look at the creature and talk about the details that need to be drawn. Talk about the texture of the creature and ask how your child might use lines to represent that texture.

WORK PERIOD:

The child draws the plant or animal he has chosen, paying close attention to detail. Encourage your child to use lines to indicate texture, too.

QUESTIONS FOR EVALUATION AND REVIEW:

Tell me about your nature study.

Show me where you used lines to create texture and detail.

How do you like this drawing?

BIG IDEA: Colors can be warm or cool. (C)

GOAL: The child will identify warm colors in a fabric leaf print.

MAIN ELEMENT: Shape

MATERIALS:

Autumn leaves of various shapes
Large piece of white cotton (or other woven fabric), about 12" X 12"
Several smaller squares of white cotton
Board *(This may be a cutting board.)*
A rock about the size of your child's fist

STRATEGY:

• Collect leaves. Notice the different colors. Ask your child if these are warm or cool colors. *(See Lesson 8, Year A to review.)*

• Demonstrate the printing technique. Place the large piece of fabric on the board. Place a leaf on the fabric. Place a small piece of fabric over the leaf. Use the rock to pound the leaf's natural dyes into the fabric until the colors of the leaf are transferred.

WORK PERIOD:

The child chooses a leaf and pounds in his own design. (NOTE: A leaf may be placed between two halves of a folded piece of fabric to make a mirror image of the leaf.)

QUESTIONS FOR EVALUATION AND REVIEW:

Tell me how you made your pattern.

How do you feel about your leaf print?

What colors are in the leaf you printed? Are they warm or cool colors? *(warm)*

BIG IDEA: Textures can be very smooth to very rough. (T2)

GOAL: The child will explore different textures in a clay print.

MAIN ELEMENT: Texture

MATERIALS:

> An assortment of gadgets for creating texture *(See p. 8.)*
> Clay
> Paints
> Paintbrush
> Paper
> Smock
> Newspaper (to protect work area)

STRATEGY:

• Both adult and child work with lumps of clay and gadgets to explore the variety of textures that can be made. Classify the textures from very rough to very smooth.

• Suggest that prints could be made by making textures in the clay, painting the clay, and using it to print on paper.

WORK PERIOD:

• The child prepares printing "stamps" by making balls of clay (about the size of meatballs). Flatten the balls slightly to make thick "pancakes". (NOTE: The clay can be left to harden for permanent stamps.)

• The child uses the gadgets to make a different texture on each pancake.

• The child brushes some paint on each clay stamp and prints it on the paper. (Often in print-making the first few prints are a bit rough, so encourage your child to make several until the prints come out more clearly.)

QUESTIONS FOR EVALUATION AND REVIEW:

Describe the texture each stamp made. Let me see if I can guess which stamp made which texture.

Which textures are rough? Which are smooth?

Which texture(s) do you like best?

BIG IDEA: Lines can suggest action and movement. (L2)

GOAL: The child will use various lines to suggest action and movement in a glue print.

MAIN ELEMENT: Line

MATERIALS:
Cardboard or styrofoam square, about 6" X 6"
Pencil
Glue
Paints
Paper
Newspaper
Paintbrush
Smock
Craft gloss

STRATEGY:

• Draw a sample design on cardboard and go over it with glue, creating raised lines. Let dry. (NOTE: If the lines don't seem raised enough, go over them with more glue.) Cover with craft gloss and let dry.

• Ask your child, "What are some ways that lines can show action?" Talk about arrows, waves, zigzags, etc. Present the idea that a line can also show action if we print it several times across a page.

• Explain to your child how you made your glue print. Demonstrate the printing technique by brushing paint on the raised lines of dried glue and pressing it onto a sheet of paper.

WORK PERIOD:

• The child chooses three lines to include in his design. He draws his design in pencil, repeating the three lines to create action or movement.

• The child applies glue to the lines of the design, then allows the glue to dry thoroughly. Touch up with additional glue, then apply craft gloss when dry.

• The child applies paint to his glue print and makes several practice prints. When the prints are giving satisfactory results, he then considers how to print the design-- across the page, diagonally, vertically, etc. After determining position, he then proceeds to print.

QUESTIONS FOR EVALUATION AND REVIEW:

Do your lines have a feeling of action or movement? How did you get this effect?

BIG IDEA: Shapes can be repeated to create patterns. (S3)

GOAL: The child will use repeated shapes to create a pattern in a fruit and vegetable print.

MAIN ELEMENT: Shape

MATERIALS: Paints *(You could also use fabric paints on a cotton shirt.)*
Paper
Paintbrush
Newspaper
Smock
Fruits and vegetable sections for printing (celery stalk, radish, carrot stick, green pepper slice, apple half, onion, potato, orange half with seeds removed, mushroom half, cabbage, etc.)

STRATEGY:

• Look at examples of patterns created by repeating shapes. (Some examples in the home may be clothing, wallpaper, floor tiles, or quilts.)

• Demonstrate the printing technique. Choose a fruit or vegetable and brush paint on the most interesting side. Press the painted side on to a piece of paper.

WORK PERIOD:

• Let your child experiment with the different fruits and vegetables to decide which shapes he likes best.

• Have the child select two different shapes he would like to use. Then discuss pattern possibilities and have your child determine the pattern he will create.

• The child prints his shapes, repeating them to create the desired pattern. (He should fill the entire page.)

QUESTIONS FOR EVALUATION AND REVIEW:

What did you do to create this pattern? *(repeated shapes)*

How do you feel about your print?

BIG IDEA: Colors can be mixed to make new colors. (C1)

GOAL: The child will mix new colors in a drip print design.

MAIN ELEMENT: Color

MATERIALS:

Paint
Paintbrush
Small and large white paper
Smock
Newspaper

STRATEGY:

• If possible, locate samples of Jackson Pollack's drip paintings in either a gallery or a library book. Notice how simple paint dripping can make striking designs.

• Demonstrate the technique for drip prints. Fold a small sheet of paper in half and open it again. Fill one side of the paper with drips of different paint colors. Fold the paper again and press the two halves together. Open the paper and observe the new colors that were made by blending the ones that were dripped.

WORK PERIOD:

• The child experiments with the drip method on several small sheets of paper. Have him predict what new color(s) will be made with the colors he has dripped.

• Have the child choose the colors he would like to use in a large drip print. The child then makes a drip print, using the large sheet of paper.

QUESTIONS FOR EVALUATION AND REVIEW:

Show me where you made some new colors. What colors made those new ones?

How do you feel about your results?

BIG IDEA: Texture adds detail and interest. (T1)

GOAL: The child will use texture to add detail and interest in a wood block print.

MAIN ELEMENT: Texture

MATERIALS:

Square, flat pieces of pine, balsa, or other soft wood
Hammer
Small metal objects with interesting shapes (screws, paper clips, nuts,
 bolts, coins, nail, screwdrivers, washers, etc.)
Crayon
Paper
Paint
Paintbrush
Newspaper
Smock

STRATEGY:

• Refer back to Lesson 9, Clay Printing. Explain to your child that, this time, instead of printing textures into clay, you will be printing textures into wood.

• Demonstrate the printing technique. Select a metal object and place it on top of a piece of wood. Tap it with the hammer-- hard enough to make an imprint in the wood, but not hard enough to damage it.

WORK PERIOD:

• Let your child experiment making different textures with the metal objects in a piece of wood.

• Have your child plan a design using the textures he likes best. (It should be something simple, like a face, a house, a boat, etc.) Encourage him to select textures that will add interest and detail.

• The child arranges his design and taps it into the wood. (At this point, the child may wish to make a crayon rubbing to see how the design will look; adjustments can be made at this time.)

• Next, the child applies paint to the wood block design and prints it on paper. (A pad of newspaper under the printing paper can sometimes make clearer prints.)

QUESTIONS FOR EVALUATION AND REVIEW:

Show me where the textures are in your wood print. Do they make the design more interesting?

BIG IDEA:　　Textures can be visual or tactile. (T3)

GOAL:　　The child will explore visual and tactile textures in a string pull design.

MAIN ELEMENT:　　Texture

MATERIALS:

18" pieces of string or yarn
Medium-size white paper
Paints
Paintbrushes
Newspaper
Smock

STRATEGY:

• Explore the different textures of strings you may have around your home-- a piano or guitar string, string toy or yo-yo, yarn in a rug or sweater, picture wire, etc. Identify which are rough and which are smooth. Comment that the different wires are textures you can **feel** (tactile), while other textures are the kind you **see** (visual).

• Demonstrate the technique for string pulls. Fold a piece of paper in half and open. Paint a piece of yarn so that it is thoroughly covered and place it on one-half of the page; fold the other half back over the yarn. Now place the paper on the table and hold firmly with one hand. With your other hand, pull the yarn out. This will leave a repeating line with a strong visual texture.

WORK PERIOD:

Let your child experiment with the technique. He can try using different colors, or using two or three strands at a time. (They can be pulled out together or one at a time.)

QUESTIONS FOR EVALUATION AND REVIEW:

How would you describe the textures you made?

Which string pull do you like best? Why?

NOTE: This lesson is not particularly related to the unit, as the painting technique is not actually used. However, collage needs to be taught to children, even though it does not exactly "fit in" with our units.

BIG IDEA: Colors can be warm or cool. (C2)

GOAL: The child will use warm and cool colors in a cut paper collage.

MAIN ELEMENT: Color

MATERIALS:

Construction paper
Pencil
Drawing paper
Color wheel *(See page 23.)*
Scissors
Glue

STRATEGY:

• Look at the color wheel and review. Which colors give a warm feeling? *(yellow, orange, red)* Which give a cool feeling? *(green, blue, purple)*

• Help your child plan a warm (or cool) background with an opposite foreground. (Some examples might be a cool-colored ocean background with warm-colored fish, or a warm-colored sunset with a cool-colored mountain.)

• Explain that your child will be making a **collage**. (This is any piece of artwork in which objects are glued onto a flat background.) Today, he will cut out pieces of construction paper and glue them onto a piece of drawing paper to make a picture.

WORK PERIOD:

• The child decides on a background (warm or cool) and cuts out pieces of those colors to form the background. These are glued onto the drawing paper.

• Next, the child chooses some objects for the foreground **in the opposite color theme** as the background. He cuts these out of colored paper and glues them onto the background.

QUESTIONS FOR EVALUATION AND REVIEW:

What colors did you use for the warm areas? The cool ones? Were you able to get those areas to look the way you wanted?

BIG IDEA: Colors can suggest a mood. (C3)

GOAL: The child will use color to suggest a mood in a wet chalk painting.

MAIN ELEMENT: Color

MATERIALS:
 Paper
 Warm sugar water (1 part sugar to 4 parts water)
 Colored chalk
 Construction paper *(Darker colors give more dramatic results.)*

STRATEGY:

• Look at the different chalk colors. Ask your child how each color makes him feel. (For example, he may say that the red makes him feel excited, while the blue makes him feel peaceful.) Explain that the mood of a wet chalk design is excitement, due to the brilliance of color this technique produces.

• Demonstrate the technique by dipping the end of colored chalk into the sugar water and drawing a simple design on the construction paper.

WORK PERIOD:

• The child experiments with the wet chalks to determine the colors and lines he likes best.

• The child plans a design and executes his wet chalk painting.

QUESTIONS FOR EVALUATION AND REVIEW:

What mood does your picture express? How did you create that mood?

Which colors seemed to glow more- lighter ones, or darker ones?

Which colors seemed to be the most exciting?

What do you like about your work today?

LESSON 17, YEAR C **Painting a la Mondrian** Date _____

BIG IDEA:	Colors can be repeated to unify a design. (C5)

GOAL: The child will repeat colors to unify a Piet Mondrian-style painting.

MAIN ELEMENT: Color

MATERIALS:

Paints (blue, red, yellow)
Brushes
Permanent black marker
Large white paper
Pencil
Black construction paper, cut into ¼"-wide strips
Newspaper
Smock
Samples of Mondrian's paintings
Glue

STRATEGY:

• Look at samples of Piet *(pronounced "Peet")* Mondrian's paintings at an art museum or in books. Ask your child to describe the paintings. Notice Mondrian's use of primary colors.

• Use the permanent marker to draw a large tic-tac-toe design on your child's paper. Subdivide the sections, making smaller square and rectangular areas. *(See sample above.)*

WORK PERIOD:

• The child decides which areas will be red, which blue, which yellow, and which will be left white. Point out that repeating these four colors throughout the painting will **unify** the design, or make everything look like it belongs together.

• The child paints each area with its designated color.

• When the paint has dried, the child glues the black strips over the permanent marker lines on the painting.

QUESTIONS FOR EVALUATION AND REVIEW:

What do you like/dislike about your painting?

Why do artists sometimes limit their colors? *(unifies the painting- makes everything look like it goes together)*

BIG IDEA: A large shape emphasizes an object's importance. (S4)

GOAL: The child will use a large shape to emphasize an object's importance in a still life painting.

MAIN ELEMENT: Shape

MATERIALS:

Large paper
Tempera paints
Water bowl
Smock
Newspaper
Easel *(optional)*
Objects to arrange in a still life (ex. flowers in a vase, fruit in a bowl,
 toys, stuffed animals, models, sports equipment)
Sample still life paintings

STRATEGY:

Look at the sample still life paintings. If there are several objects in the still life, how does the artist show which object is the most important? Point out the samples where the artist uses size to show which object is the most important. If there is only one object, is it painted small or large? Explain that often the artist will make an object large to show how important it is.

WORK PERIOD:

• The child chooses an object for his still life painting and places it in the position he chooses near the painting area. (He may arrange other objects around it, if he desires.)

• The child paints the object (and surrounding objects, if desired), "thinking big" as he paints.

QUESTIONS FOR EVALUATION AND REVIEW:

Tell me about your still-life painting.

Which object is the most important in the painting? How did you show this? *(by making it large)*

What do you like about your work today?

110

LESSON 19, YEAR C **Still Life II** Date _____

BIG IDEA: Shapes can be combined to make objects. (S2)

GOAL: The child will observe how shapes combine to make objects in a still life painting.

MAIN ELEMENT: Shape

MATERIALS:

Tempera paints
Brushes
Water bowl
Large paper
Newspaper
Smock
Easel *(optional)*
Grouping of toys to paint

STRATEGY:

• Look together at the arrangement of toys. Can the child find a round shape (perhaps a bear's ear, or a car wheel)? Have the child trace the shape with his finger. Can the child find a triangular shape? A shape like a square? Point out how the shape is **like** a circle, triangle, or square, but notice how it is different. (This is important, because it helps the child describe what he actually sees, rather than using symbols to stand for parts of objects.)

• Help your child see how the shapes combine to make the toy. (For example, a bear may be a collection of round shapes; a car may be a combination of rectangular shapes and round shapes.) Discuss two or three more toys, having your child describe the shapes he sees. (Some children may need to trace the shapes with their fingers as they describe them.)

WORK PERIOD:

• The child selects three toys and arranges them into a still life.

• The child paints his still life, combining the shapes he sees.

QUESTIONS FOR EVALUATION AND REVIEW:

Show me the shapes you used to make each object.

BIG IDEA:	Lines can be used to express an idea. (L4)

GOAL:	The child will use line to express an idea in a full body self-portrait.

MAIN ELEMENT:	Line

MATERIALS:	Paints *(NOTE: To make flesh color, mix white, orange, and a dab of blue; for darker skin tones, mix brown and white)*

Large paper
Newspaper
Smock
Water bowl
Clothes for dressing up, or costumes
Full-length mirror
Polaroid camera *(optional)*

STRATEGY:

• Have your child select some clothes for dressing up. Look together at your child in the mirror. Try out different poses and have your child select the pose that best expresses his idea for his painting.

• If possible, take the child's picture with the camera. (If not, study the child's pose in the mirror.) Notice how the different lines made by the child and his costume express his idea-- the curved lines of a cowboy hat, the soft lines of a ballet tutu, the flowing lines of an evening gown, the angled lines of a karate stance.

• Tape the child's picture where he can see it, or have him work near the mirror where he can pose for his portrait.

WORK PERIOD:

The child paints his self-portrait, using the photo or mirror as a guide. Encourage him to concentrate on the lines he is using. (NOTE: The child will probably need two sessions to complete the portrait. However, if he completes it in one session, he can use the second session to do another portrait.)

QUESTIONS FOR EVALUATION AND REVIEW:

Tell me about the idea you had. Show me the lines that express your idea.

112

BIG IDEA: Forms have roundness. (F3)

GOAL: The child will observe that forms have roundness while constructing an armature for his papier mâché animal.

MAIN ELEMENT: Form

MATERIALS:
Newspaper
Cardboard
Cardboard tubes (from toilet paper, paper towels, etc.)
Paper cups
Masking tape

STRATEGY:

• Look at pictures of animals. Talk about the interesting features that each animal has. How is the picture of the animal different from a real animal? Point out that pictures are flat and only show one side of an animal; animals are round and can be seen from many different sides. A picture only give the **shape** of the animal; a real-life animal is called a **form** because it is round and has different sides.

• Tell your child that he will be making a sculpture of a real animal. In this session, he will be making the **armature**. This is the framework underneath the sculpture that makes it strong.

• Demonstrate how an armature can be built. Roll tubes of newspaper and secure them with tape to make long, round parts (like bodies, legs, or necks), or use cardboard tubes instead. Balls of newspaper can be used for round parts. Talk about different ways these parts could be combined to make an animal. (For example, a large newspaper roll could be the body, cardboard tubes could form the legs, a newspaper ball could be the head, a paper cup could form the snout, and pieces of cardboard could make the ears. All these pieces could then be taped together.)

WORK PERIOD:

• The child decides on an animal he would like to make and describes features that are special to that particular animal (ex., a pig's curly tail, a fish's fins, a cow's horns).

• The child builds the armature, turning it to check it from all angles. (Remind him that he is building a **form**. Forms are different from shapes in that they have roundness and can be viewed from all sides.)

QUESTIONS FOR EVALUATION AND REVIEW:

Is your armature sturdy enough? Do you need to make it stronger? How?

How will your sculpture be different from a picture of the animal? *(It will be round and have sides.)*

113

BIG IDEA: Forms can be representational. (F1)

GOAL: The child will create a representational form using papier mâché.

MAIN ELEMENT: Form

MATERIALS: Newspaper, cut or torn into long strips
Metylan® instant wallpaper paste, reconstituted with water according to package directions *(Metylan® can be found in paint stores. A small box will make enough for several projects and is inexpensive. Other instant pastes will work as well, but wheat pastes tend to spoil.)*

STRATEGY:

Cover the work area with sheets of newspaper. Demonstrate the papier mâché technique.
- Dip strips of newspaper into the paste. Draw each strip between two fingers to remove the excess.
- Place the wet strips of newspaper over the armature until it is covered.
- For the succeeding layers, use a different technique. (This keeps the sculpture from getting too soggy.) Dip your fingers into the paste and tap them on a strip of newspaper. Smooth the damp strip onto the wet armature. Continue until the second layer of newspaper strips is completed. Then rub this layer until the paste from the first layer soaks through and all lumps and air bubbles have been removed. Add paste with your fingers whenever the newspaper strips seem too dry.

WORK PERIOD:

The child covers his armature with papier mâché strips. He will need to use several layers to achieve the desired shape. Remind him that this form is to be **representational**; that is, it will represent, or show, a real animal (not an imaginary one). Details such as horn, tails, scales, fins, etc., may be added at any time. (Strengthen the base where the extra piece attaches by using several layers of papier mâché.) Remind your child to turn the armature as he works to make sure all sides of the piece are considered.

QUESTIONS FOR EVALUATION AND REVIEW:

Tell me about your papier mâché animal.

What details did you add to make your sculpture look like the animal you chose?

Do you like using papier mâché? Why or why not?

BIG IDEA: Colors can be mixed to make new colors. (C1)

GOAL: The child will mix colors to make new colors to paint his papier mâché animal.

MAIN ELEMENT: Color

MATERIALS:

Tempera paints
Brushes
Muffin tins or cups for mixing colors
Water bowl
Newspaper
Smock
Popsicle sticks, plastic spoons, or coffee stirrers

STRATEGY:

Have your child decide on the colors he wants to use for his papier mâché animal. (Refer back to a picture of an animal to help him.) Remind him that this form is to be **representational**, or life-like, so colors should be chosen appropriately. When he mentions a color you do not have (such as brown), point out that you do not have that color of paint, but it is possible to **make** the color he desires.

WORK PERIOD:

• Assist the child in mixing the colors he wants in the muffin tin or cups. (This will help minimize waste and spills.) Refer back to Lesson 15, Year A, to find out how to mix particular colors. Have the child stir the colors, using popsicle sticks, plastic spoons, or coffee stirrers.

• The child paints his papier mâché animal. Remind the child to paint all sides of the creature, because forms have roundness.

QUESTIONS FOR EVALUATION AND REVIEW:

How do you feel about your papier mâché animal?

Were you able to mix the colors you needed? How did you make them?

BIG IDEA: Shapes can be repeated to unify a design. (S5)

GOAL: The child will repeat shapes to unify a foil and ink design.

MAIN ELEMENT: Shape

MATERIALS:
Sturdy piece of corrugated cardboard, 12" X 15"
Pencil
Scraps of tagboard and cardboard
Scissors
Glue

STRATEGY:

• Look at samples of bas relief in library books or at an art museum. (Pronounce "bas" to rhyme with "pa". "Bas" is French for "low"; "relief" refers to being raised from the background.) Some examples you may find in your home are coins, Cameo® soap, pottery or plastercraft, etc. Have your child look at the examples and notice how the figures "stick up" from the background.

• Explain that repeating a shape in different parts of a design can **unify** the design, or make everything look like it belongs together.

• Demonstrate the technique. Cut a few shapes from cardboard and glue them to a base.

WORK PERIOD:

• The child choose two or three shapes he would like to repeat to create a bas relief.

• The child cuts the shapes from cardboard, cutting several of each shape. (The shapes can be traced to obtain exact duplicates.)

• The child then glues the shapes onto the cardboard base, repeating different shapes throughout the design to create unity. He may wish to make some shapes stand out more by using thicker cardboard or by gluing two or more shapes on top of each other; lower shapes can be created by using tagboard.

QUESTIONS FOR EVALUATION AND REVIEW:

Which shapes are higher (more raised)? Which are lower? How did you get them that way?

Which shapes did you repeat? What does repeating shapes do for your design? *(Makes it look like everything belongs)*

116

BIG IDEA: Textures can be repeated to unify a design. (T4)

GOAL: The child will repeat textures to unify a foil and ink bas relief design.

MAIN ELEMENT: Texture

MATERIALS:
Glue
Water bowl
Yarn or string
Brush
Aluminum foil
India ink or black tempera paint *(NOTE: A few drops of liquid dish detergent added to the paint will help it stick to the foil.)*
Paper towels
Newspaper
Smock

STRATEGY:

• Discuss the bas relief that the child made during the last session. Explain that he is going to make his bas relief more interesting.

• Demonstrate the foil and ink technique. Take your cardboard sample from last week and use a brush to cover it with glue. Place aluminum foil over the design, pressing it into the nooks and crannies around the shape. Dip a paper towel in the ink or paint and rub over the foil.

• Talk about the sample. What texture does the foil have? How does the ink change the way the foil looks? *(It emphasizes the texture, reduces shine, gives depth.)* Notice how the repeated texture all over the design pulls the different shapes together. Last session we repeated shapes to unify the design; this session we will use texture to unify the design.

WORK PERIOD:

• The child brushes glue over his design and carefully covers it with aluminum foil. Encourage him to press the foil tightly around the different raised shapes.

• Next, the child rubs ink or paint into the foil, leaving more behind in the recesses and less in the raised areas. (If desired, the design can be buffed with a soft cloth to heighten the effect.)

QUESTIONS FOR EVALUATION AND REVIEW:

Explain how you unified your design. *(repeated shapes and texture)*

LESSON 27, YEAR C **Clay Forms I** **Date _____**

BIG IDEA:	Forms can be non-representational. (F1)

GOAL:	The child will construct non-representational forms with clay.

MAIN ELEMENT:	Form

MATERIALS:

Clay
Heavy fabric or old vinyl tablecloth, about 12" square
Two rulers or wooden slats about ¼" thick
Rolling pin
Fork and knife
Various forms (cans, boxes, blocks, balls, ice cream cone, etc.)

STRATEGY:

• Look at samples of modern sculpture, either at an art museum or in library books. (Some public buildings and schools have pieces of modern sculpture on their lawns.) Talk about the forms that your child sees-- spheres ("balls"), cubes, cones, cylinders, etc.

• Talk about the differences between modern sculpture and the papier mâché animal your child made. The animal was **representational** because it showed something as it really is; modern sculpture is **non-representational** because it does not show any particular object. (NOTE: Many people have confused non-representational and abstract art. Abstract art is a separate style which is loosely representational.)

• Demonstrate making slabs of clay. Place a lump of clay on top of the fabric; place one ruler on either side of the clay. Run the rolling pin over the rulers to form a perfectly flat pancake of clay. Peel the pancake away from the fabric. The slabs can be cut into different shapes or rolled into a cone, cylinder, or sphere.

• Demonstrate how to join two slabs of clay. Scrape over the two edges to be joined with a fork, making a rough surface. Moisten the roughened edges with water and press them together. (Explain that roughening the surfaces first makes a tight bond that will not come apart.)

WORK PERIOD:

The child sculpts three different forms, using clay slabs he has rolled.

QUESTIONS FOR EVALUATION AND REVIEW:

Tell me about your clay forms.

What is the difference between representational and non-representational art?

118

BIG IDEA: Forms can be useful. (F2)

GOAL: The child will apply paints and textures to clay forms to make decorations.

MAIN ELEMENT: Color, texture

MATERIALS:

Paints
Mod Podge® craft gloss
Newspaper
Brush
Water bowl
Smock
Paper
Clay forms from last session
Old toothbrush
Cotton swabs
Sponges

STRATEGY:

• Discuss different possibilities for color combinations. Let your child experiment on paper. Some combinations to try include *related colors* (such as magenta and orange, turquoise and violet), *metallics* (These are especially good for sculptures and are now available in tempera paints.), *white and black combinations*, and *primaries* (red, blue, yellow).

• Discuss and experiment with different texturizing techniques, such as *sponging*, *stippling* (spattering paint by rubbing your finger across an old toothbrush), and *dotting* (using a cotton swab).

WORK PERIOD:

• The child decides on a color combination and a texturizing technique, painting the clay forms as he has planned.

• When the paint is dry, the child applies a coat of craft gloss to seal the colors. (NOTE: Metallic paint tends to dull under craft gloss. You may wish to have your child experiment on paper first to decide if he prefers a glossed or un-glossed finish.)

QUESTIONS FOR EVALUATION AND REVIEW:

(Wait until the craft gloss is clear and dry.)

Tell me about the colors and textures you chose.

119

BIG IDEA: Colors can be repeated to unify a design. (C5)

GOAL: The child will use repeating colors to unify a painted shirt design.

MAIN ELEMENT: Color

MATERIALS:
Fabric paints (available at any craft store)
Large tee shirt
Cardboard or old manila folder
Masking tape
Crayons
Scratch paper

STRATEGY:

• Visit a craft store with your child and look at the fabric paints. Have your child select two or three colors that go well together. (A general rule of thumb is to keep the color families together: neons, metallics, pastels, brights, etc. Choosing colors from the same family will tend to harmonize the design.)

• At home, look at samples of patterns that have repeating colors (such as floor tiles, clothing, wallpaper, etc.). Point out how repeating colors throughout the design pulls everything together and makes everything looks like it belongs. This is called creating **unity** in a design.

• Tape a piece of cardboard to the inside of the tee shirt to keep the fabric in place while the child is painting.

WORK PERIOD:

• The child selects crayons that match the colors of fabric paint he has chosen. He then uses these colors to experiment with different designs on scrap paper. He may want to include a small, alternating color pattern with which to "frame" the design.

• The child paints his design onto the tee shirt with the fabric paints.

QUESTIONS FOR EVALUATION AND REVIEW:

How do you like your shirt design?

Tell me how you chose those colors. How do they go together?

What did repeating colors do to your design? *(makes everything look like it belongs together)*

120

BIG IDEA: Large shapes emphasize an object's importance. (S4)

GOAL: The child will use a large shape to emphasize an object's importance in a diorama.

MAIN ELEMENT: Shape

MATERIALS:
Scissors
Construction paper
Glue
Markers
Shoe box

STRATEGY:

• Ask your child about his favorite storybook, Bible, or historical characters. Can your child describe an exciting event from a well-loved story?

• Explain that a diorama is a special way to tell a story. People and "props" are cut from paper and glued into the shoe box to make the scene. The character or object which is the most important is made large and is placed furthest to the front.

• Help your child decide on a particular scene, characters, and props. Demonstrate how to make paper tabs that can be attached to objects to make them stand up. (A simple tab to make is a small rectangle, folded in half lengthwise to make a capital "L". Glue the vertical side of the "L" to the object and the horizontal side of the "L" to the floor of the shoe box.)

WORK PERIOD:

• The child selects a scene, two or three characters, and props for his diorama. These are drawn on construction paper, colored (if desired), and cut out. The character that is the most important should be larger than the others and should be placed in the front.

• The child lines the box with appropriate background colors. Include the sides, ceiling, and floor.

• The child cuts the various pieces and uses tabs to fasten them to the box. (NOTE: Tabs may be used to suspend props from the ceiling, such as clouds, sun or moon, balloons, birds, airplanes, kites, etc.)

Because this is a rather involved project, let your child know he has another session for adding details.

QUESTIONS FOR EVALUATION AND REVIEW:

Tell me what is happening in your diorama story. How did you show which object/character is the most important? *(made it large and placed it in the front)*

BIG IDEA: Texture adds detail and interest. (T1)

GOAL: The child will add textural details to add interest to a diorama.

MAIN ELEMENT: Texture

MATERIALS: Same items as last session
String
Fabric
Sand
Aluminum foil

STRATEGY:

• Review the paper sculpture techniques from Lesson 26, Year B.

• Discuss what areas of the diorama would look more interesting if textural details were added. (For example, grass could be created by using fringed green paper; accordion-folded paper could create window blinds; paper curls could be used for hair.) Consider using the string, fabric, sand, or foil to add textural interest to the diorama.

WORK PERIOD:

The child adds textural details to add interest to his diorama.

QUESTIONS FOR EVALUATION AND REVIEW:

How do you feel about your diorama now? Do you think it is more interesting? Why or why not?

What textures did you add to your diorama? How did you make them?

LESSON 32, YEAR C **Papier Mâché Container I** Date _____

| **BIG IDEA:** | Forms can be useful. (F2) |

| **GOAL:** | The child will create a useful form with papier mâché. |

| **MAIN ELEMENT:** | Form |

| **MATERIALS:** | Metylan® wallpaper paste, prepared according to package directions
Newspaper strips
Large bowl or box
Plastic food wrap
Smock
Newspaper sheets (to protect work area) |

STRATEGY:

• Look at different containers in your house. Which are the most useful? Which are the most decorative? Which are the most interesting? Based on this discussion, help your child select a bowl or box he would like to use as a mold.

• Review the papier mâché technique from Lesson 22, Year C.

• Cover the outside of the selected bowl or box with plastic food wrap.

WORK PERIOD:

The child uses the papier mâché process to cover the outside of the bowl or box with several smooth layers.

QUESTIONS FOR EVALUATION AND REVIEW:

Tell me how you might use your container.

How might you decorate your container? What colors might you use?

BIG IDEA: Colors can be repeated to make patterns. (C4)

GOAL: The child will use repeated color to create patterns on a papier mâché container.

MAIN ELEMENT: Color

MATERIALS:
Tempera paints
Small brushes and cotton swabs
Large bowl or box, covered with papier mâché, from last session
Smock
Newspaper sheets (to protect work area)
Water bowl
Scratch paper
Craft gloss

STRATEGY:

• Carefully remove the papier mâché container from the bowl or box. Discard the plastic food wrap.

• Discuss possible color combinations that could be used on your child's papier mâché container. (Refer back to Lesson 28, Year C, for some ideas.)

• Explain that a pattern is created when colors are repeated. Talk about the different patterns your child could make with the colors he has chosen. (For example, if your child has chosen primary colors, he could make a pattern by repeating red, yellow, red, blue, red, yellow, red, blue, etc.)

• Have your child experiment making patterns on the scratch paper and choose one for his container.

WORK PERIOD:

• The child selects three colors with which to make a pattern.

• The child paints a background color all over his container (inside and out).

• After the background color has dried, the child paints his design all over the container.

• After the paint has dried, the child seals the colors with craft gloss.

QUESTIONS FOR EVALUATION AND REVIEW:

(Wait until the craft gloss has dried.)

Show me the patterns you created with your colors. How did you make them?

LESSON 34, YEAR C **Paris Craft® Finger Puppets I** Date _____

| BIG IDEA: | Forms can be representational. (F1) |

| GOAL: | The child will use representational forms to create finger-puppets. |

| MAIN ELEMENT: | Form |

| MATERIALS: | Paris Craft® (plaster-impregnated gauze strips used by medical personnel to make plaster casts; available at medical supply stores) |

Newspaper
Scissors
Bowl of warm water

STRATEGY:

• Motivate your child by looking at and discussing puppets. (You could attend a puppet show, play with puppets at home, or look at puppets at a toy store or in library books.) Point out the many different kinds of puppets- marionettes, shadow puppets, rod puppets, hand puppets, finger puppets, etc.

• Talk about the kind of finger puppets your child might like to make. (It may help if your child thinks of a story first and then decides which puppets he will need for that story.) Tell your child that puppets are **representational** because they look like real people, animals, etc.

• Demonstrate the Paris Craft® technique. Moisten strips of Paris Craft® with warm water and smooth them around your finger. Continue layering the strips until the desired thickness and size is obtained. Allow the strips to harden before removing the puppet from your finger.

WORK PERIOD:

• The child selects three or more finger puppets he would like to make.

• The child uses the Paris Craft® strips to make the finger puppets. *(Explain that the child will paint the finger puppets during the next session.)*

QUESTIONS FOR EVALUATION AND REVIEW:

How did you like using the Paris Craft®?

What finger puppets are you going to make? Why do we call them **representational**? *(because they look like real things)*

BIG IDEA: Colors can suggest a mood. (C3)

GOAL: The child will use various colors to suggest different moods with finger puppets.

MAIN ELEMENT: Color

MATERIALS:
Tempera paints
Small brushes
Water bowl
Newspaper
Smock
Finger puppet casts, from last session

STRATEGY:

• Ask your child to describe what moods certain colors suggest to him. (Ask questions such as, "How does white make you feel? Black? Red?") There are no correct answers; let your child express his thoughts.

• Share with your child that colors have come to be associated with different moods through the years. Some of these are:

Black- sadness Purple- majesty
Red- love or excitement Green- jealousy
Yellow- cowardice Orange- boldness
Blue- truthfulness Pastels- gentleness
White- purity

WORK PERIOD:

The child assigns each finger puppet a different color and mood and paints it accordingly. After the paint has dried, he adds details to each puppet.

QUESTIONS FOR EVALUATION AND REVIEW:

What mood does each puppet express? How did you get that mood? *(by the color used)*

What do you think of your puppets? Which do you like best? Why?

Can you make up a play for your puppets?

126

LESSON _____ , YEAR C Title: _____ Date _____

BIG IDEA:

GOAL:

MAIN ELEMENT:

MATERIALS:

STRATEGY:

WORK PERIOD:

QUESTIONS FOR EVALUATION AND REVIEW:

LESSON _____, YEAR C Title: _____ Date _____

BIG IDEA:

GOAL:

MAIN ELEMENT:

MATERIALS:

STRATEGY:

WORK PERIOD:

QUESTIONS FOR EVALUATION AND REVIEW:

128

THE ART FIELD TRIP

When most parents think about a field trip, they think about visiting an interesting historical site, science center, aquarium, or zoo. Rarely do we link together the ideas of "art" and "field trip" in our minds. The fact remains, however, that almost any experience outside of the home school that results in learning could be classified as a "field trip". Many times great benefit can be derived from an excursion that is specifically planned in relation to art.

Why an art field trip?

Why would a parent want to plan an art field trip? If you have read through the lessons in this book, you will notice that many of them suggest visiting a particular place before beginning the actual lesson. This provides motivation for the child to continue with the art instruction. A trip to a museum or art gallery could also provide an opportunity for a parent to assess or reinforce a child's knowledge of a concept that has been taught. (For example, if you have taught the idea that forms have roundness, a visit to a sculpture exhibit could give your child an opportunity to demonstrate his understanding of the concept.) An additional benefit of a trip planned for this purpose is that children also have an opportunity to use their art vocabulary.

Another reason for an art field trip might be to find interesting subjects for drawing. Parks, zoos, city streets-- all can be exciting stimuli for a child's artistic expression. Field trips can be conducted purely for informational purposes as well. Children can learn much about career possibilities and specific techniques by observing artisans at work; also, crafts conducted in an historical setting often give fascinating glimpses into life long ago.

One of the best reasons for an art field trip, however, is to help your child develop an appreciation for art. An important first skill is to teach the child, not to glance hurriedly at a work of art and continue, but to take time to stop and **see**. Children can be taught to develop a critical eye if we as parents ask appropriate questions. For example, you may ask your child any of the following:

- Where does your eye go first in this piece? Second? Third?
- What medium was used (paint, chalk, etc.)? How would this picture be different if the artist had used a different medium?
- What technique was used? How would this picture be different if the artist had used a different technique?
- What kind of work is it (painting, print, etc.)?
- Form "picture frames" with your fingers and look at different parts of the piece. Which parts are the most interesting? Why? (Remember, with a form, you must go all the way around the piece.)
- Can you describe the piece with your eyes closed?
- What feeling does the picture give you? How would you feel if you were in it?
- Do you like the title of this piece? Do you think it's a good choice? Why or why not?
- What do you think the artist is trying to say?
- *(If other pieces by the same artist are being displayed)* How is this piece like the others? Different?
- How would this picture look if it were larger/smaller? Done in a different color scheme?
- How would you change this piece, if you were the artist?

Answering questions such as these will help a child begin to think critically about art and to appreciate its unique place in the world.

Places to go

Many locations provide educational opportunities in the field of art. Of course, there are art museums and galleries, which may offer reduced or free admission for students. Colleges may also feature art displays, and some may allow children to observe classes. Craft stores or fairs allow children to view pieces of useful art and sometimes provide an opportunity to see craftspeople at work. (Don't overlook historical or cultural sites, either; many have exhibits or demonstrations of crafts related to that time period or culture.) A final possibility would be private studios. All of these locations offer wonderful opportunities for art field trips, depending on your purpose.

Field trips with young children

No matter how wonderful the trip you have planned, it can easily be shipwrecked by a child's inability to meet your expectations. Young children have special needs that must be considered in planning a field trip of any kind.

First, young children have very short attention spans (20-30 minutes maximum). This is not the age to plan covering an entire museum; select just a specific display or exhibit that relates to your instructional purpose and plan to do other areas at other times. It is also a good idea to take your child at a time of day when he is more likely to be rested and attentive (which is usually the morning hours for most children). Your child will get much more out of the trip, and, besides, it's much better for a child to leave desiring more than to leave wishing he'd never come in the first place.

Young children also need structure and order; that is, they will feel more secure if they know ahead of time exactly what to expect in this new situation. It will help your child tremendously if you find out the location's rules ahead of time (such as "no touching") and explain them with any of your own before going out on your excursion. Some children also benefit if you can explain to them exactly what you will be doing. ("First we'll park in a big garage, then we'll walk three blocks to the museum," etc.) Young children who are given structure in this way will feel more comfortable about the field trip experience and will be more likely to concentrate on its educational aspects.

The field trip process

Never has the Boy Scout motto been truer than when planning a field trip-- "Be prepared!" You can prepare yourself for the trip by finding out as much about the location as you can beforehand. (In fact, if at all possible, visit the field trip site ahead of time to note such details as parking arrangements, cost of admission, stroller accessibility, location of rest room and/or lunch facilities, etc.) It also helps if you know exactly what you will be seeing so you can guide your child's learning more accurately. You will also want to prepare your child for the trip, as explained in the previous section.

Once you are on your way, the rule with young children is "be flexible". You may want to have some games or alternate activities planned if last minute changes should occur.

Depending on the location of your field trip, a small first-aid kit and a trash bag may come in handy. While it is important to stay focused on the objective of your trip, you should feel free to follow your child's interest and attention span. (If you are visiting a craft show, for example, and you wanted your child to concentrate on the technique of weaving, do not become upset if he shows more interest in the different textiles that are being used.) If you notice that your child has become tired and has lost all interest, don't try to "stick it out" to the end. It is much better to end the field trip early than to have it be remembered as a stressful experience.

After the field trip, follow-up activities can help the child remember what was learned on the trip. Sometimes just a simple discussion (or reporting to other family members) may be all that is necessary, but you may also want to consider a follow-up project as well. For example, your child could draw a picture of what he saw on the field trip. He could also write a "report" about the trip (or dictate one to you, if writing skills are not yet developed) or even write a story. (Possible story topics might include "If I Were The Artist", "If I Were In This Piece of Artwork", or "What Happened in This Artwork".) He could also try to reproduce a certain artwork or technique. Following up a field trip in some form will help impress the experience into your child's mind and reinforce the learning that took place.

The world is a big place, and it contains so many interesting things to learn. Taking your child on field trips will not only reinforce what you teach in your classroom, but it will also expose your child to the many exciting experiences that lie outside your classroom door.

GLOSSARY

abstract- a shape or form taken from an actual object and altered

additive method- a method of building onto a clay sculpture by adding pieces (These pieces must be scored and moistened before attaching them to the main piece.)

armature- the framework which undergirds a sculpture

bas relief- "low" sculpture, which is slightly raised from the background

batik- a process by which a substance blocks the absorption of paint or dye into a fabric or paper

binder- the part of paint that holds the color together and "binds" it to the surface to which it is applied

blind contour drawing- a line drawing executed while looking only at the subject

collage- a collection of textures glued to a flat background

complementary colors- colors that are opposite on the color wheel (ex., red and green)

contour- the imaginary line around an object's edges

craft- an art object created for a specific use

diorama- shapes within a box, usually depicting a scene

form- a three-dimensional object, which can be viewed from all directions

Impressionism- a style of painting in which objects were not painted exactly, but with quick brush strokes to give an "impression" of that object

landscape- a panoramic drawing or painting of the earth's natural features (excluding oceans or seas)

limited palette- a technique in which the artist limits his color choices

mobile- shapes or forms suspended in space

modified blind contour- a line drawing executed by looking primarily at the object

monoprint- a print that can be done only one time

mosaic- an art form which gets its shapes and colors from adhering many small pieces of colored stone, tile, paper, etc., to a flat base

mural- a painting or drawing which covers a wall

non-representational- a design not meant to suggest or represent any object; a design

papier mâché- a sculpture technique in which paper strips and paste are applied to a framework

Pariscraft®- plaster-impregnated gauze used for making casts

pastel- created by mixing a color with white; also called "tint"

pigment- the colored part of paint

pinch-and-pull method- a method of sculpting clay by pulling and pinching parts of a basic ball shape

portrait- a painting or drawing of a person

primary colors- red, yellow, and blue (These colors cannot be created by mixing others.)

representational- an art form made to look like a person or object

sculpture- a three-dimensional piece of art

secondary colors- orange, green, and violet (These are made by mixing two primary colors together.)

shade- created by mixing a color with black (ex., hunter green, maroon)

shape- a flat object; that is, it has only two dimensions (ex., circle, square)

stencil- a shape cut from cardboard, used to repeat that shape in an art piece

still life- a drawing or painting of arranged objects

tactile texture- texture you can feel

textile- any material that is woven or knitted, such as fabric, yarn, etc.

texture- the degree of roughness or smoothness that an object has

tint- created by mixing a color with white (ex., pink, lavender)

unity- the feeling that everything in an art work belongs to the piece

visual texture- texture you can see, but not feel

warp- the threads that make up the framework of a weaving

wax resist- a technique in which wax is used in a drawing to prevent an area from absorbing paint

weft- in weaving, the threads which are woven over and under the warp

134

BIBLIOGRAPHY

Brookes, Mona. Drawing With Children. Los Angeles: Jeremy P. Tucker, 1986.

Edwards, Betty. Drawing on the Right Side of the Brain. Los Angeles: J. P. Tucker, 1979.

Gaitskell, Charles D; Al Hurwitz, and Michael Day. Children and Their Art. New York: Harcourt, Brace, and Javonovich, 1982.

Jenkins, Peggy D. Art for the Fun of It. Englewood Cliffs, NJ: Prentice-Hall, Inc., 1980.

Linderman, Earl W., and Marlene M. Arts and Crafts for the Classroom. New York: MacMillan, 1977.

Linderman, Marlene M. Art in the Elementary School. Dubuque, IA: William C. Brown Publishers, 1984.

Solga, Kim. Build Art! Cincinnati: North Light Books, 1992.

Solga, Kim. Draw! Cincinnati: North Light Books, 1991.

Solga, Kim. Make Gifts! Cincinnati: North Light Books, 1991.

Solga, Kim. Make Prints! Cincinnati: North Light Books, 1991.

Solga, Kim. Make Sculptures! Cincinnati: North Light Books, 1992.

Solga, Kim. Paint! Cincinnati: North Light Books, 1991.

Wachowiak, Frank, and Theodore Ramsey. Emphasis: Art. New York: Intext Educational Publishers, 1971.

INDEX

The following index will help you select lessons that can be incorporated into a unit-study curriculum. A topic is given, followed by the lesson number which relates to the topic.

AT HOME PUBLICATIONS

This book is published by At Home Publications, a family business dedicated to meeting curriculum needs. We also publish the Masterpak, a set of art reproductions for use with this program, as well as *Early Education at Home*, a curriculum guide for preschool and kindergarten.

To order additional materials, please complete the information below.

Name _____

Address _____

Phone _____

Email address _____

Age(s) of child(ren) _____

Materials ordered: Early Education at Home Qty. _____

Art Adventures at Home, Vol. 1 Qty. _____

Art Adventures at Home, Vol. 2 Qty. _____

Art Adventures at Home, Vol. 3 Qty. _____

Masterpak Qty. _____

Costs are $24.95 per book and/or $15.00 per Masterpak.

SUBTOTAL _____

Add $5.00 shipping and handling _____

AMOUNT ENCLOSED _____

Please make checks payable to:
 At Home Publications, 2834 Grier Nursery Road, Forest Hill, MD 21050.